In Great Decades : Two

In Great Decades : Two

CARAVAGGIO

A PLAY IN TWO ACTS

Michael Straight

Devon Press : New York/Berkeley : 1979

LIBRARY OF CONGRESS CATALOGING IN PUBLICATION DATA

Straight, Michael Whitney.
 Caravaggio.

 (His In great decades; book 2)
 1. Caravaggio, Michelangelo Merisi de, 1573-1610—Drama. I. Title.
II. Series.
PS3569.T678C37 812'.5'4 79-17678
ISBN 0-934160-00-7
ISBN 0-934160-02-3 pbk.

Caravaggio is volume two of the set, *In Great Decades*, by Michael Straight. The other volumes are:

I *Happy and Hopeless* (a novel)
III *Trial by Television & Other Encounters* (essays)
IV *Twigs for an Eagle's Nest: Government and the Arts: 1965-1978*

The Setting

Michaelangelo Merisi lived from 1573 to 1610. He called himself Caravaggio, after the village in Northern Italy where he was born.

He was born into a family of artisans. At ten, following the death of his father, he broke with his family tradition and became an apprentice in the workshop of a Milanese painter, a follower of Leonardo. He served out his apprenticeship; then he made his own way to Rome.

Rome at that time was emerging from the austerity of the Counter Reformation. The days of the "holy" popes had passed; the princes of the Church lived as princes again. Cardinal Francisco Maria del Monte, for one, held elaborate banquets in his palace at which, according to contemporary records, music was played by youths dressed in tunics and sashes.

The artistic establishment of Rome was dominated by the Academy of Saint Luke. Its founder and president, Federigo Zuccari, was an heir of Raphael and an honorary citizen of Rome. Those privileged to associate with him in the Academy were bound by its rules. They state: "No one in the Academy shall dare to act otherwise than in a virtuous and modest way ... but ... shall be law abiding and peaceable, and shall in no manner provoke trouble." Zuccari's purpose, plainly, was to

secure the position and rank of the painter in the social hierar-
chy of Rome. In turn he would ensure that painters would
conform to the artistic requirements laid down by the Church in
the Council of Trent. They were laid down in detail, and they
were written to be enforced, as Paolo Veronese discovered when
in 1573 he was summoned before the Tribunal of the Holy
Office of the Inquisition for introducing dogs, dwarfs, and a
servant with a bleeding nose into his painting, *The Feast in the
House of Levi*. As the Tribunal reminded him, none of these
details was mentioned in the Holy Scriptures.

In the dominant art of the period, the letter of Catholic
doctrine is adhered to; the spirit of Christianity is abandoned.
Typically, in Zuccari's painting of the Ascension the Saint, a
shapely blonde is borne up to Heaven by adoring *putti*. Her
nakedness, accentuated by a seductive limb, is tantalizing. Her
modesty, like Lady Godiva's, is an artifice, protected by her long
tresses of endlessly combed hair. She and the angels who
serenade her on her way seem unaware of any experience
beyond the boudoir and incapable of any feeling, save vanity.
Except for one small corner of the painting, where the crucifix-
ion can be seen, as through a keyhole, there is no suggestion that
the Saint is a leading participant in a tremendous event—one
charged with passion and agony, and the promise of redemption
for all humanity.

Into this world came the adolescent Caravaggio, unknown
and penniless. He lived in poverty and squalor, painting pictures
of flowers and fruits that other artists sold. He almost died in a
paupers' hospital. In his *Boy with Fruit*, the so-called *Bacchino
Malato*, he painted what is thought to be a self-portrait after he
had contracted malaria. He is sallow, ugly, with the snub nose,
thick lips and heavy eyelids seen later in the drawing of him by
Ottavio Leone. Yet he is appealing. He wears a wreath of ivy,
happy perhaps to be alive.

A year or two later he was taken into del Monte's palace as a
member of his household. He painted the Cardinal's youths as
The Musicians. He painted a series of youths in the same spirit,
and presumably for the same circle of patrons: the lovesick boy
now in the Borghese Palace, the androgynous boy in the Her-

mitage (who was taken until recently to be a girl), the metaphorical Bacchus in the Pitti Palace, the impudent and seductive boy in Berlin. In these works and others of the period he stands apart from the Academy painters and close to another innovator: Annibale Carraci. But as they move into the larger and more sensitive realm of sacred subjects, Caracci's hand is guided by his iconographical advisor, Monsignor Agucci, while Caravaggio stands alone.

Once again, in assessing his purpose and his influence it is useful to contrast Caravaggio's treatment of sacred subjects with the approaches of his great predecessors. Thus, the Conversion of Saint Paul is portrayed by many sixteenth century masters. Raphael's tapestry in the Vatican is splendid in design and as static in concept as a conventional stage set. The stock centurion lies on his back in the stock attitude; his companions rush toward him, as if he had just been struck down by an enemy's spear. In the background is the well-groomed, passive figure of Jesus. The work deals in externals; it is literal and does nothing to arouse the imagination of the beholder.

Michelangelo's portrayal of the same scene in the Capella Paolina is a still more splendid spectacle. The human figures are paired to give balance and tension to the scene; the centerpiece and keystone of the composition is the rearing horse. The shaft of light from Heaven is only one element in a crowded sky. Like Raphael's, the work is literal and deals only in externals. Succeeding works by Tintoretto and Rubens simply accentuate these characteristics. All elements are important in these paintings; with minor alterations they can be transformed into portrayals of cavalry battles. They are spectacular, clamorous, very much of this world.

Caravaggio's painting of the Conversion of Saint Paul is in Santa Maria del Popolo in Rome. It owes nothing to the great works which preceded it and stands in the sharpest contrast to them. Saul lies in the foreground, stunned and senseless. The light which blinds him comes from no visible source; it is divine light. Saul's horse and servant are flooded by the light, but they are not aware of it. The horse, which could not rear up or lead a charge, raises one leg to avoid stepping on its fallen rider. The

servant looks down, perplexed and motionless, at his master. The painting deals in internal experience and emotion; it leaves a great deal to the beholder and so binds the beholder to the scene as a participant. It is earthy, but not earth-bound.

Again, the Calling of Saint Matthew is treated in a formal, static manner by a few Italian masters in the fifteenth century. It is portrayed frequently and coarsely by Dutch painters. In their scenes, which are genre paintings at heart, they portray a tax collector interrupted in lechery by one who, were he on earth today, might be an agent of the Treasury, or a clerk bearing a summons from a Congressional committee.

In Caravaggio's painting, the light once again is low and from an unknown source. The brilliant colors of Matthew's companions, uncomprehending as they are, are overcome by the invisible bond that is created between the Saint-to-be and the Saviour. Standing in shadow, Jesus is silent and obscure; he does not command, he beckons. His gesture is caught across the darkness by Matthew's arm and carried to his heart. In a moment of incredulous recognition he asks: is it me?

The most familiar of sacred subjects is, of course, the Virgin. In early doctrine the Virgin was seen as the abstract impersonation of the one who, according to Isaiah, was to be the Mother of the Saviour. For three centuries following the crucifixion she was not portrayed in human terms. From then on, Gnostic sectaries began to endow the Virgin with human attributes, drawing on pre-Christian legends. Thus, the legend of the passing of the Virgin was composed in the East. It was condemned by Pope Gelasius in the fifth century. Nonetheless, as Christianity spread, it incorporated into its doctrines legends that were deeply embedded in non-Christian communities. The legend of the passing became, in time, accepted doctrine, portrayed by the painters whose works Gregory praised, as "the bible of the illiterate."

The legend tells how Mary in her old age was overcome by a desire to be with her son. An angel appears to her and tells her that her wish will be granted. The apostles are brought by angels to her bedside, and in the third hour of the night Christ enters her chamber with a host of angels, patriarchs, martyrs, prophets

and confessors and a choir of virgins. "Come, thou chosen among women," He says, and her soul flies into his arms. So, without pain she passes through death to life everlasting. This scene is portrayed in the twelfth century mosaics in Palermo. It is repeated in all essentials by masters from Giotto to Fra Angelico. The uniformity of their approach suggests a stable doctrine, but in fact, the origin, nature and passing of the Virgin were subjects of continuous and at times threatening disputes within the Church. Until the end of the thirteenth century, leading theologians denied that Mary was immaculately conceived and held that she had died. Thus, Saint Bonaventure declared: "If the Blessed Virgin was free from Original Sin, she was also exempt from the necessity of dying. Therefore her death was an injustice; or, she died for the salvation of the human race. But the former supposition is blasphemous, implying that God is not just; and the latter is a blasphemy against Christ, for it implies that His redemption is insufficient. Both are erroneous. Therefore, Our Lady was subject to Original Sin."

The debate continued for centuries: a cutting edge between Europe and Byzantium, between the Middle Ages and the Renaissance. The Renaissance brought a shift of emphasis. As if to avoid the enervating effect of doctrinal disputes, commissions were given and paintings executed to portray the Ascension of the Virgin rather than her dormition. From Pinturicchio on, the Virgin gains in youth and vitality; she reaches a high point of vigor in Titian's monumental work in the Frari in Venice. When Titian and his contemporaries, Tintoretto and Veronese, departed, they took conviction and self-confidence with them, leaving insipidity and pretentiousness as the dominant characteristics of late sixteenth century art.

Caravaggio's painting, *The Death of the Virgin*, was commissioned by the Spanish Order of the Discalced Carmelites. They expected a picture expressive of their doctrine that the Virgin passed through death without dying; Caravaggio painted a dead woman and gave them what he saw and knew to be true. Baglione and Bellori tell us that the painting was rejected by the Carmelites because it portrayed a corpse. Giulio Mancini adds that the painting was removed because Caravaggio had used a

courtesan as his model. "One can see how much harm the modern painters do," he adds. "If they decide to depict Our Lady, they portray her as some filthy whore from the slums." It was charged further that Caravaggio's model had fallen, or jumped, into the Tiber and had drowned.

The painting, banished by the Carmelites, was bought by the Duke of Mantua on the advice of Peter Paul Rubens. It could not be shipped at once. "I found it necessary," the Duke's agent wrote to him, "in order to gratify the Painters Guild, to let the picture be placed on display all week long. Many of the most famous painters have been flocking to see it, for, although scarcely anyone had been allowed to see it, it was the talk of the city."

The irony is plain. Zuccari and the Academy painters reach for the miraculous and grasp only the commonplace. Caravaggio paints the commonplace and, Bellori tells us, the young painters of Europe hail his pictures *come miracoli*—as miracles.

The Death of the Virgin, like all of Caravaggio's paintings, is perfectly controlled. But it is the work of one who, in contrast to the members of the Academy, was always in trouble; who regarded "virtue and modesty" as poses; and who in his brief life was never peaceable. Baglione describes him as "haughty and mocking"; Bellori, as "contentious and turbulent." Del Monte describes him as a *cervello stravagantissimo*, that is, an almost ungovernable man. He stayed out of prison for as long as he lived in del Monte's palace; that presumably was a measure of the Cardinal's ability to control Caravaggio, or to influence the police. From 1600 on, however, he was constantly in the courts. The rejection by the Carmelites of *The Death of the Virgin* was followed by a fight in which Caravaggio was stabbed and his opponent killed. He fled and was banished from Rome. He was thirty-four and penniless. He could not wait for the one thing he had to have: a Papal pardon. He went to Naples and then to Malta. There, he painted the Grand Master and in turn was made a Knight, despite his status as a fugitive.

In July, Caravaggio was inducted into the Holy Order. In September, he was cast into the Dungeon of San Angelo. In October, a Criminal Commission of the Order reported that he

had escaped and fled. In December, he was tried *in absentia,* "deprived of his habit, expelled, and thrust forth like a rotten and fetid limb from our Order and community." He fled from Malta to Syracuse, from Syracuse to Messina, from Messina to Palermo, from Palermo to Naples. There, in 1609, a band of *bravos,* the hired assassins of the time, trapped him and slashed his face. Disfigured, feverish and penniless, he hid in a garret in Naples. Then he sailed north, past Civitavecchia to Porto Ercole, a fortified harbor under Spanish rule. He planned perhaps to wait there until his pardon arrived. Instead the Spanish Viceroy cast him back into prison. By the time he was released, the *felucca* which brought him had sailed on its return journey, carrying his belongings. This, Baglione tells us, "made him furious. In his desperation, he started out along the beach under the cruel July sun," (the "Lion Sun," as Baglione calls it). He collapsed on the beach, died, and was buried in an unmarked, and to this day unknown, grave.

Caravaggio left no sketches, no diaries, no letters. He is known to us through his works, and they are revealing. *The Martyrdom of Saint Matthew,* to cite one painting, shows a scene of controlled violence. The killer could be any young man seen on the streets of Rome. The Saint cannot see, beyond his hate-contorted face, the angel's palm of martyrdom. Others in the scene, armed as some are, recoil in fear. Caravaggio himself is among them. His face is anguished; he cannot move. But he is not a detached onlooker, standing at a safe distance; he is a witness, a participant; he is involved.

Again, in *David and Goliath* the boy who holds the severed head of the giant is hastily painted in a generalized way. Goliath, in contrast, is highly individualized. He is, almost certainly, a self-portrait. The choice of the metaphor is significant. A romantic under similar circumstances might have portrayed himself as Prometheus, punished by the Gods for bringing hope and fire to men. Caravaggio portrays himself as an enemy of society, brought down by a boy. His face is filled with pain, but he is no martyr. He asks for nothing; he records himself as he sees himself, as he is.

For the iconoclast, success can be a disaster. In his lifetime

and after his death Caravaggio was imitated by countless Caravaggisti who borrowed his technique but lacked his perception. So, for two centuries he stood in low repute. At the same time men who were themselves innovators drew what they needed from him and went their own ways. Georges de la Tour, Velazquez and Rembrandt are all in some measure his heirs. Today his values, as well as his works, are universally accepted; so much so that it is hard to believe that by painting as he did he placed his livelihood, and perhaps his life, in jeopardy. Even in his defiance he helped to establish the artist's right to his or her own vision. By creating a direct relationship between the beholder and the work, and by sensing the divine in his immediate surroundings, he opened up, as Rudolf Wittkower noted, a vast new area in art and beyond art.

* * *

How did one who was born the son of a mason in a provincial village come to paint *The Calling of Saint Matthew* and *The Death of the Virgin*? That plainly is a central question for one who seeks to present Caravaggio's life and character. It can be argued, as Walter Friedlaender suggests, that when he moved to Rome, Caravaggio came within the inspired circle of Filippo de' Neri. It can be argued with equal force that fidelity to nature, rather than religious conviction, was the key to Caravaggio's treatment of sacred subjects. Taken separately or together, these explanations cannot account for the depth of perception contained in the two masterpieces. Is Caravaggio's growth and transformation between 1596 and 1602 attributable to his response to the demands made upon him, and to the responses of his contemporaries to his works? Caravaggio's early biographers, who were uniformly offended by his character as well as by his works, offer no answers. Nor did Roberto Longhi, who did so much to restore Caravaggio's reputation in this century, and with whom I spent a day shortly before his death. Friedlaender considers the alternatives in his book, *Caravaggio Studies*. He concludes:

> The marked changes in the character of his expression might be
> taken as an indication that something happened in his outward
> life, or his inner experience, which influenced and altered the
> natural development of his personality, but we have no evidence
> as to what it might have been.

Rather than speculating on "what it might have been," I have
worked from what is known or what may be projected from the
known as being plausible. Inhibiting as it is, I have limited
myself in this way in the belief that the writer who draws his
material from historical sources should restrain his imagination
in return. Nonetheless, when the record is so sparse, specula-
tion is unavoidable. As in all historical fiction, those whose
curiosity is aroused are left asking: Where are the boundary
lines? Here then, are a few footnotes.

Act one, scene one. The Musicians, which Baglione and
Bellori state was done for Cardinal del Monte, almost certainly
shows the youths of his household. Denis Mahon dates it be-
tween 1594 and 1595, when Caravaggio was about twenty-two.
Longhi suggests that the eldest of the youths is a self-portrait. If
so, it is romanticized. The painting was found in England only
recently and is now in the Metropolitan Museum. While it is
generally calm and harmonious, a close examination reveals
that one of the strings of the lute is broken.

The song is my own free translation of *Non Peccando Altri
Che'l Core*, one of the *frottole* of B. Trombocino.

Act one, scenes two and three. The encounter with Father
Firmo is taken from a curious but detailed account of this
incident given by Mancini. In citing an example of Caravaggio's
outlandish and eccentric behavior, Mancini describes how his
brother, a priest, traveled to Rome to see him. Cardinal del
Monte, according to Mancini,

> . . . sent for Michele and confronted him with his brother, but
> Michele said he did not know him and that he was not his
> brother. To this the poor priest replied, "Brother, I have come a
> long way to see you, and having seen you, I have fulfilled my
> desire . . . I do not need you for myself, . . . but rather for your own
> children, if God would allow me to arrange a marriage for you. . . .

I will pray to the Divine Majesty for you and I know our sister will do the same in her chaste and virginal prayers." But Michele was not moved by these heartfelt words, and the good priest left without so much as a goodbye from his brother.

Act one, scene four. The episode with the waiter is taken from the Complaint of Pietro da Fosaccia, a waiter in the Tavern of the Blackamoor. Caravaggio, he states,

> . . . was eating with two men in the Tavern . . . I had brought him eight cooked artichokes, to wit, four cooked in butter and four in oil. The said defendant asked me which were done in butter and which in oil. I replied: 'Smell them, and you will easily see which are cooked in butter and which in oil.' Thereupon he flew into a rage and without further words seized an earthen plate and flung it in my face. . . . Then, he snatched the sword of one of his companions . . . perhaps with intent to strike me.

Act one, scene five. All of the three cases in court are taken from the records, save that the verses are my own free version of the offending lines. The Magistrate's errors in citing Pasqualone's name and profession are duly recorded, and may be taken as an indication of his regard for the notary.

Act one, scenes three, six and seven. Mancini states that Caravaggio "used a courtesan as the model" for the Virgin in the *Madonna of Loreto* and the *Madonna del Serpe* which were completed in 1604 or 1605, and which may well have been begun at an earlier date. The *Madonna del Serpe*, in turn, seems close in the unusual coloring of her hair and in other features to the dead woman in *The Death of the Virgin*, which was begun in late 1605. Mancini notes that the Virgin in this painting "resembled a courtesan."

As to the relationship between Caravaggio and Lena, Pasqualone testified under oath on July 29, 1605, that "a few nights ago he [Caravaggio] and I had words on the Corso on account of a girl called Lena who is to be found on the Piazza Navona. . . . She is Michaelangelo's girl."

Writing later without supporting evidence, G. B. Passeri says that a poor but honorable young girl who lived with her mother was induced by Caravaggio to serve as his model. He adds:

This girl was being courted by a young man who was a notary by profession and who had asked the mother for her daughter's hand in marriage. However, he had always received a negative answer because this simple and naive woman was unwilling to give her daughter to a notary since, as she said, all notaries are surely bound for damnation. The young man was indignant at this refusal, but he did not lose track of his beloved. Thus, he found out that she frequently went to the house of Caravaggio and remained there for long periods of time, posing for him. Full of jealousy and totally enraged, he contrived to meet the mother and said to her, "My good woman . . . you have made a choice . . . worthy of your class in refusing to let your daughter marry a man like me so that you can make her the concubine of this excommunicated scoundrel. Now, you can keep her, and I hope it will do you a lot of good!"

The mother, Passeri adds, complained to Caravaggio who then sought out and struck the notary.

Passeri's account is a sentimentalized elaboration of a recorded sequence of events. It seems reasonable to assume that Caravaggio painted Lena at least twice when she was living and once when she was dead. Was Pasqualone correct in asserting, under oath, that she was Caravaggio's "girl"? If she drowned, and it seems that she did, was it by accident or by intent? There is no way of knowing. There is some evidence, on the other hand, that Caravaggio was drawn strongly and at times compulsively to adolescent boys. In general, relationships with others, men or women, may not have been critically important to one who was intensely egocentric, as many artists are, and who was primarily and passionately concerned with his own work. Sensing this, and lacking any strong convictions which could be fitted into the available framework, I've sketched the outlines of a relationship between artist and model, choosing not to dwell on it, nor to attempt to bring it to the foreground in sharp focus.

Act one, scene seven. Father Peter Villagrassa is described by contemporaries as one of the foremost orators of his time. The scene is in outline similar to an incident in the life of Rubens, as described by Michael Jaffe.

Act two, scenes one and three. In general the comments of the Grand Master and the Lord President are based upon mate-

rial in the archives of Catholic University and the Library of the
Knights in Rome. The description by the page of the bonfires
held on feast days is taken from historical records.

Beyond this, what happened when Caravaggio, the icono-
clast and rebel, placed himself within the jurisdiction of an au-
tocratic, absolutist Order? It is known that he painted the Grand
Master and His Page. It is asserted that the Grand Master is also
portrayed in his painting of Saint Jerome. It is generally accepted
that it was at the insistence of the Grand Master that Caravaggio
was made a Knight of Grace on July 21, 1608.

And then? Baglione tells us:

> Michaelangelo had a dispute with a Cavaliere di Giustitia and
> somehow insulted him. For this, he was thrown into prison, but
> he escaped at night by means of a rope ladder and fled to the island
> of Sicily.

Bellori, adding colorful details to Baglione's account of Caravag-
gio's initial good fortune in Malta, continues:

> But, all of a sudden, his turbulent nature brought this prosperity
> to an end . . . because of a very inopportune quarrel with a most
> noble Cavaliere, he was thrown into prison and was subjected to
> misery, fear and maltreatment. At great personal risk, he man-
> aged to escape from prison in the night, and fled, unrecognized to
> Sicily with such speed that he could not be overtaken.

These accounts are based upon the official, published records of
the Order. They include the Report of the Criminal Commis-
sion of October 6, the further Order, convening the General
Assembly, and finally, the Expulsion Order of the Assembly.
This Order states that the information gathered having been
carefully read, the Assembly determined that Caravaggio,
"while detained in the prison of the Castle of San Angelo, did
escape by means of ropes from the said prison, and without
permission . . . did depart from the district. . . ."

No further information was ever made public by the Order
as to the quarrel with the unnamed Knight, the proceeding
which led to Caravaggio's imprisonment, or the circumstances

of his escape from prison and his flight from Malta. Nonetheless, historians from the time of Baglione to the present have accepted at face value the summary statements contained in the Expulsion Order.

Faith Ashford who attempted to obtain further documentation on Malta itself was told in 1935 that the records were unavailable. Still hopeful, I flew to Malta in 1967. The authorities were most cooperative. Some were intrigued by my plan to write a play about Caravaggio; others accepted it as an amusing cover story. The British were moving out of Malta; the Russians were ready to move in; CIA agents with their cover stories were common enough.

I asked the Archivist of the Royal Maltese Library if I might have access to his records on Caravaggio. He regretted that none were available. We continued to talk. He proved to be the Senior Knight on the island, and I asked him for his opinion on Caravaggio's transgression, detention, and escape. He suggested, in response, that I visit the old fort of San Angelo and then dine with him in Mdina.

The next day I went in a naval launch to the fort. I climbed its steep, cobbled approaches and the steeper steps that led within its immense walls—the walls that had withstood four months of continual bombardment by the Turks in the Great Siege in 1565. I passed underground armories and torture chambers; I came out on the highest and most inaccessible level of the fort. There, capped by a heavy stone disc, was the Oubliette, a cone hollowed out of the rock in which Caravaggio had been held as a prisoner in 1608.

I lowered myself into the Oubliette by means of a rope ladder. It was twenty feet or so to the stone floor, and the floor was about ten feet in diameter. On the rough walls were scrawled the last messages, some in English, of Knights who for many centuries had been placed there until they were hauled up to be executed.

That evening, I walked along the amber-lit streets of the pre-Christian town of Mdina to the address I had been given. The Senior Knight was waiting for me.

"Well?" he said.

"I know only one thing," I said. "He didn't escape."

My friend nodded and said: "Go on."

"The story about the rope ladder cannot be true," I said. "Someone rescued him."

"Who?" asked the Knight. "Bear in mind," he added, "that the Governor of San Angelo was responsible only to the Grand Master. Bear in mind also that when the Grand Master La Cassiere was held there by a usurper, only the providential intervention of a visiting Apostolic Delegate saved him, the Oubliette was so secure.

"Remember also," he continued, "that getting out of the Oubliette was merely the first step in escaping from that well-guarded and impregnable fortress.

"Who then," he asked, "rescued Caravaggio from the Oubliette and placed him on a boat for Sicily?"

"The Grand Master," I said.

"Of course. But why?

"Remember," he said, "that if Caravaggio had been caught in some transgression by any other knight or by a guard he would have stood trial and both the charges and the proceedings would have been known. Who was it then who caught him?"

"The Grand Master."

"Of course. He placed him in the Oubliette to gain time. But he did not bring him to trial. Why not?"

"I don't know."

"Think," said my friend. "Think about the regulations of our Order. Chastity, for example, is compulsory. No women are permitted here, certainly not for the pleasure of the leading knights. But pages? A knight must have a page. Sodomy of course is forbidden. Knights might be blinded for looking on pages with lustful eyes. And yet . . . no knight was ever charged with sodomy, but many were tried and punished for 'acts against nature.' If you were Grand Master, and I was Caravaggio," he said, "how would I expect to paint you?"

"By myself?"

"Exactly. And how is the Grand Master painted?"

"With his page."

"You know about Caravaggio. You know of his reputation."

"Yes."

"Well?"

"The Grand Master catches Caravaggio with his page."

"Go on."

"He arrests him, but he cannot bring him to trial."

"To do so would be to reveal his own role. Go on."

"He puts him in the Oubliette. He keeps him there while he arranges his escape. He brings him out at night and places him on a boat sailing for Sicily. Then, he has him tried and condemned and expelled from the Order for escaping without his permission."

"And the advantage of that?"

"No charges are made; no records are kept."

"An interesting theory," said my friend, the Knight.

It seems plausible from the viewpoint of the Grand Master. How then are we to account for the actions of Caravaggio? Was he driven by a compulsive attraction for the page? The boy is blond and phlegmatic, a far cry from the lovesick youths of del Monte's household. Was it his blind need to wound men in authority; men who helped him? He had so much to gain by excercising some restraint. His overriding aim, presumably, was to get back to Rome. If the Grand Master was determined to keep him on Malta, could the page have become an accomplice in some conspiratorial plan for his own selfish reasons? None of these elements by itself seems adequate to account for Caravaggio's transgression. Together would they suffice? It seems much easier at first sight to suppose that in one of his outbursts he lashed out at some real or imagined antagonist. But then, why the concealment and the elaborate subterfuge in all that followed?

Act two, scene two. The scene is an abridged version of the ancient ceremony of the Order.

Act two, scene four. Baglione plainly implies that the *bravos* who disfigured Caravaggio were agents of the Knight with whom he quarreled on Malta. Bellori again embroiders the story.

> [Caravaggio] felt that it was no longer safe to remain in Sicily and
> so he . . . sailed back to Naples, intending to remain there until he
> received news of his pardon so that he could return to Rome. At
> the same time, seeking to regain the favor of the Grand Master of
> Malta, he sent him as a gift a half-length figure of *Salome*. . . .
> These offerings availed him nothing; for, stopping one day in the
> doorway of the Osteria del Ciriglio he found himself surrounded
> by several armed men who manhandled him and gashed his face.

Roger Hinks holds that the *bravos* were agents of the unnamed
Knight. An alternate story asserts that the *bravos* were hired by
a Sicilian schoolmaster who sought revenge on Caravaggio on
behalf of his students. My friend on Malta maintained that the
Grand Master would not have stooped to this action.

<p style="text-align:center">* * *</p>

 Jane Costello and Rudolf Wittkower read the play as art
history; others reviewed it as drama. Thornton Wilder made
suggestions for several scenes (Father Firmo's lines, ". . . Stub-
born . . . stubborn," are typically his). I remember him best,
pounding the luncheon table at the Century and shouting: "Stop
talking scandal! Act it out!"

 Helpful as these friends were, the experience in the theatre
of what came to life and what lay lifeless counted the most for
me.

 Four early versions of the play were produced: by the Vine-
yard Players of Ithaca College in 1968, the H. B. Studio in 1969,
the Gallery Circle Theatre of New Orleans in 1970, and the
Playhouse-in-the-Park in Cincinnati in 1971. Each production
had its moments of panic, despair, hilarity and deep-seated
delight. In Vineyard Haven the small boys who were cast as del
Monte's protégés asked their parents who they were supposed to
be and the parents rebelled. In the H. B. Studio so many actors
were drawn off to do television commercials that Herbert Berg-
hoff had to impress passers-by on Bank Street to fill out the cast.
In New Orleans George Patterson held rehearsals in a loft filled
with recumbent drug addicts. (To everyone's relief they iden-
tified at once with Caravaggio.) In Cincinnati local boosters

organized a banquet in the manner of Cardinal del Monte, at which the *pièces de résistance* were an African antelope and a black bear flown in for the occasion.

A play about a painter cries out for color and form in the sets. Given the bare walls of a school gymnasium and two matchbox stages, we did what we could with music in the first three productions, starting and ending the play with Orlando di Lasso's *Matona Mia* and *Cara*, playing records of his motets *Tui sunt Coeli, Timor et Tremor, Tribulationem,* and *Tristis est Anima Mea* between the scenes. Accidents occurred, of course, and in New Orleans only the passionate conviction of the painter who played Caravaggio and the disc jockey who doubled as the Cardinal and the Grand Master could surmount the moments at which moustaches and beards became unstuck and pants fell down.

In Cincinnati I encountered, for the first time, a full-size theatre, a stage that was deep and wide, a professional cast and a professional crew. I went to my first conference and found Word Baker and Jo Mielziner bent over a diagram of the theatre and marking entrances and exits, electrical circuits and lighting platforms; I felt with a sense of elation that I was in good hands. Word made a pageant of many scenes: ending the Tavern brawl with a riot that broke out in every corner of the theatre, and holding the audience in darkness until, in the investiture, rows of robed and hooded knights strode down the aisles with flaming torches. He hid whatever doubts he had from his young cast, and celebrated the final performance by taking to the stage himself as Master Roccasecca who was, at that moment, three days old. As for Jo . . . he came up with a system of projections so powerful and intricate that the city engineers took steps to ensure that Cincinnati would not be blacked-out on the summer evenings when the cast and the Cincinnati Reds were both performing. In the final scene, written as a *stretto*, Jo outdid himself. He said later:

> I took fragments of Caravaggio's best paintings, but never a whole picture, never a rectangle. From a Madonna I'd cut out the head, one arm, the corner of her robe. These I'd superimpose on elements from another painting. All of these things were shaped

fragments in color ... making a collage. When actors walked through it, it was wonderful! ... A melange of light! It's the first time I've ever seen it work. There were moments when an actor's face would disappear. And suddenly, the Virgin's hand would appear on his shoulder! ... I must have had fifteen or twenty projections on at one time.*

"*Caravaggio*," said Jo, "was a happy marriage of the stage techniques best suited for the qualities of the play." Needless to say, the marriage could not last for long. The H. B. Studio production cost $25 for coffee and doughnuts handed out to the cast; the New Orleans production cost a few hundred; the Cincinnati production cost $75,000, and the stage manager estimated that it would take $250,000 to move it to New York. No way; but it was all worth while. Few experiences can equal the moment of elation felt by the playwright when the characters who have existed only as shadows come to life on the stage.

*"*Caravaggio* in Collage: Jo Mielziner Creates a Projection Spectacular." *Theatre Design and Technology*, February 1973.

Cast

MICHAELANGELO MERISI, called CARAVAGGIO

GIOVANNI BAGLIONE, a painter
CARDINAL FRANCESCO MARIA DEL MONTE
PRINCE
ANDREA, a page
FATHER FIRMO
LENA
ONORIO LONGO, a painter
FILIPPO TRISEGNI, a painter
PIETRO, a waiter
MAGISTRATE
CORPORAL OF THE GUARD
MARIANO PASQUALONE, a notary
MASTER ROCCASECCA
FIRST FISHERMAN
SECOND FISHERMAN
THIRD FISHERMAN
FATHER PETER VILLAGRASSA
THE VENERABLE FERDINAND
FATHER DOMINIC
FATHER THOMAS
ALOF DE WIGNACOURT, Grand Master, the Knights of Malta
THE REVEREND LORD PRESIDENT, the Knights of Malta
THE GRAND MASTER'S PAGE
THE GRAND PRIOR
ANTONIO, a boy in Naples
FISHERMAN'S WIFE

PAGES, FRIARS, KNIGHTS

Act I: The Urchin

Act II: The Outcast

Act I

PROLOGUE AND SCENE I

[*As the lights dim,* TWO MEN, *seated near the front of the theatre, keep up their laughing chatter.*

BAGLIONE, *dressed in the manner of a cavalier, moves down an aisle. As he passes the* TWO MEN *one cries out in a menacing manner,* "Eh! . . . Bagaglia!" *Both men laugh at* BAGLIONE's *evident fear.*

BAGLIONE *hurries past the two men. He crosses the stage and turns.*]

BAGLIONE. Malnati! [*To himself.*] Bagaglia! . . . They'll bury me with that nickname hung around my neck!

[*To someone in the audience.*] It was Merisi, hung that nickname on me, may he roast his backside in hell! "Gian Bagaglia," he used to call me. And "Gioan Coglione." And . . . well, . . . we'll skip that one, seeing as there are ladies present.

[*He sits on the balustrade and introduces himself.*] Giovanni Baglione. Painter. And a scholar, an Art Histo-

rian if you please. You know my magnum opus: *Lives of
the Painters, Sculptors and Architects. . . .* Well . . . I threw
a few architects in there; just to fill it out . . . You know
the book? You've read the chapter on Merisi? It's one of the
best, right? And I'll tell you why. I knew him, as he *really*
was.

Caravaggio. That's what he called himself. Michael-
angelo Merisi da Caravaggio. As if he were Leonardo da
Vinci! And that's how he thought of himself! I swear it!

Mind you, he could paint. If he painted a bunch of
grapes, your mouth would begin to water. If he painted a
lizard, you'd shiver for fear it would crawl off the canvas
and up your leg. Let's face it, no one in all Europe, no one,
could paint better than Merisi.

But what did he paint? That's the question! Pictures
that Their Eminences wanted? A ray of light from up there
to give us a bit of hope; or else a glimpse of what's down
there, awaiting us, if we don't keep to the straight and
narrow; that's what Their Eminences want! And that's
what we painters give them, those of us who know what's
good for us. Better a live Catholic than a dead heretic, eh?
But try to tell that to Merisi!

They made a bonfire out of Giordano Bruno, right here
on the Campo, remember?

[*In a low voice.*] It's not for me to say, of course, but
just between us, who was the greater heretic: Bruno with
his silly theories, or the one who called himself Caravag-
gio?

[*He sits shaking his head. In the background the
sound of a lute being tuned can be heard. Caravaggio's
self-portrait, in his* Martyrdom of Saint Matthew, *rises
slowly in projection.*]

"No hope; no fear," that was his motto. Damned and
defiant; he was that way from the start.

[*The sound of the lute grows louder. Laughter can be
heard offstage. A soft warm light rises on a reception room in
the Palace of* CARDINAL DEL MONTE. FOUR BOYS *are grouped in*

the foreground, as they are seen in Caravaggio's painting The
Musicians. *They wear Doric chitons and scarlet and green
sashes. The youngest plucks at a bunch of grapes. The lutenist
tunes his instrument. An older boy grips a curved horn. The
fourth boy sits, studying a score.*

The laughter gains in volume; CARDINAL DEL MONTE, *and
the* PRINCE *enter. The* PRINCE *could be the man shown in the*
Portrait of a Man in Black *by Veneto, in the Thyssen Collec-
tion. He is supercilious, but not effeminate. When he is not
talking, he cleans his teeth with a gold toothpick.*

DEL MONTE *is forty-five. He is the representative of the
Grand Duke of Tuscany in the College of Cardinals. As such,
he is a prince of the realm rather than a priest of the Church.
But although he is sybaritic and self-centered in this scene,
there is within him a core of conscience and belief that will
become dominant in his old age.*]

PRINCE [*still laughing*]. . . . no, no, no, no, no, no, no, no, NO!
. . . My dear del Monte, I must protest! You had me at your
mercy and you showed no compassion! I tried to resist, but
what was I to do?

DEL MONTE. Give in to temptation, as we all do.

PRINCE. What else could one do? The pâté . . . perfection! . . .
The scampi, superb! . . . As for the larks! How joyously
they would have sung had they known that they were
destined to be served up in such a sauce!
[*Eyeing the four boys.*] And now . . . there are other
larks, waiting to sing?

DEL MONTE. My little musicians . . . They are young and inex-
perienced . . .

PRINCE. My dear friend . . . *ils sont ravissant!* . . . Come, you
must present them.

DEL MONTE [*yielding*]. Ambrogio . . . Ippolito . . . Andrea . . .
Not the names their fathers gave them of course. They had
some very common names when I found them.

PRINCE. You found them?

DEL MONTE [*his hand on the bare shoulder of the violinist*]. Ambrogio was an acolyte in whom one of our priests had taken an unfortunate interest; I did my duty.

PRINCE. Of course!

DEL MONTE [*stroking the hand of the horn player*]. Ippolito was a pickpocket; a very good one too, with these delicate fingers. He'd be rich by now if he hadn't tried to rob a captain of the guard.

IPPOLITO [*smiling*]. A sergeant.

DEL MONTE. A captain sounds better. They were hot on his heels . . .

PRINCE. And you sheltered him! How compassionate! And, how farsighted! For now, of course, he can't afford to leave you . . . unless . . . unless an even more powerful patron . . . [*He lingers at the side of* IPPOLITO.]

DEL MONTE [*lifting the lutenist's chin*]. This is Andrea. We found each other one evening at Rospigliosi's. He had a minor role in a masque. I spotted him at once, and as he passed my chair, I whispered a little proposition in his ear.

PRINCE. He must have been livid.

DEL MONTE [*preoccupied*]. Who?

PRINCE. Rospigliosi; when you stole his . . . protégé.

DEL MONTE. He stormed a little. He talked about his cousin in the Curia. What could he do? [*They laugh.*]

PRINCE. And the little one?

DEL MONTE. He was left at our hospital, shivering with fear. And now . . . there's nothing more to fear, is there Alessandra? Nothing save time.

PRINCE. So . . . these are your treasures. Four charming young . . .

DEL MONTE. There's a fifth somewhere. Where is he?

IPPOLITO. In the kitchen eating!

AMBROGIO. That's all he does, is eat!

DEL MONTE. Well . . . [*ruffling* AMBROGIO'*s hair*] run and fetch him, or we'll have no food left.
[AMBROGIO *runs out.*]

PRINCE [*still picking his teeth*]. Another musician?

DEL MONTE. A painter.

PRINCE. A painter! Isn't that rather . . . recherché?

DEL MONTE. Not at all. Everyone of substance keeps a painter now. As an investment. You give him a room to work in. And he's yours.

PRINCE. And how will you use him?

DEL MONTE. I shall guide him to the fine, the rare, [*He is looking at the musicians.*] the beautiful.

PRINCE. Your dining table, garnished with . . .

DEL MONTE. My little musicians. He will paint them as they are now. Then they will sing forever. They will still be young when I am old and feeble. And long after I'm gone, the world will know what treasures once were mine.

PRINCE. Nonetheless . . . if what you say . . . but, how can . . .

DEL MONTE. Hmn? . . . Oh, I don't say it will be easy. But give me time, Prince, give me time and I promise you this urchin I picked up from the gutter . . .
[CARAVAGGIO *is standing in the doorway. He is small, dark, above all else, intense. In sharp contrast to the musicians, he is unkempt, awkward, ill-clad, self-reliant; he is himself. He holds a bunch of grapes and continues to munch them. Even when the* PRINCE *is speaking to him, he may be spitting the pits into his hand and looking for a place to put them.*]
Ah! There you are.

PRINCE. But . . . he's ugly!

DEL MONTE. Very ugly.

PRINCE. He looks like . . . an oversized dwarf!

DEL MONTE. Yes . . . Come here, boy! . . . Closer! [*He nudges the* PRINCE.] Tell us what you've been doing.

CARAVAGGIO. Eating. [*Snickering among the musicians.*]

PRINCE. Excellent! You too find His Eminence's table irresistible.

CARAVAGGIO. I was hungry. [*More snickering.*]

PRINCE. Splendid! A healthy appetite is a gift from God.

CARAVAGGIO. I'm always hungry. [*More snickering.*]

PRINCE. Bravo! Much as I relish good food, I too make a point of reminding myself, even at the best of tables, that my next meal is already in preparation, and that I must prepare for it, by exercising a modicum of self-restraint.

CARAVAGGIO. I eat the last scrap. Then . . . [*Glaring at the musicians.*] . . . I lick the plate!

PRINCE. You do?

DEL MONTE. What he means to say is that he has not known at each meal where his next meal is coming from.

PRINCE. But . . . everyone knows where his next meal . . .

CARAVAGGIO. You do. We don't.

PRINCE. And who, pray, is the royal "we"?

CARAVAGGIO [*looking at* DEL MONTE]. We urchins. From the gutter. [*A pause.*]

PRINCE [*to* DEL MONTE]. Well! . . . What name will you give to him?

CARAVAGGIO. My name is Michaelangelo Merisi.

PRINCE. Yes . . . quite . . . but, that's a . . . a trifle pretentious. People might think that you were confusing yourself with the great Michaelangelo.
 [*To* DEL MONTE.] What is he to be called?

CARAVAGGIO. I am to be called Caravaggio.

PRINCE. Oh ! Very good! I like that! It has a . . . rustic sound.

CARAVAGGIO. It's the name of the village where I was born.

PRINCE. Quite. And I like it. I like people who acknowledge the humble circumstances of their births.

CARAVAGGIO. It's what many great painters did.

PRINCE. Great painters? I don't follow you.

CARAVAGGIO. Veronese . . . Pordenone . . . Romanino . . . They called themselves after the places where they were born.

PRINCE. Well! [*To* DEL MONTE.] He really does have a rather grandiose conception of himself—this urchin of yours.

CARAVAGGIO. I think of myself as the greatest living painter. [*A pause.*]

PRINCE. My dear boy! You're not serious!

CARAVAGGIO. I am! [*The* PRINCE *glances at* DEL MONTE. *He nods.*]

PRINCE. He is? Well . . . every dog is entitled to his own opinion.

CARAVAGGIO. The world will share my opinion before I'm finished.

PRINCE. Will it? . . . Well! . . . I wish you luck!

CARAVAGGIO. Luck?

PRINCE. Well, what . . .

CARAVAGGIO. There is work, work to the point of exhaustion! There is concentration so that when he's working, the

painter doesn't . . . he doesn't know if it's raining or shin-
ing outside, if it's night or day!

PRINCE. What I meant to say was . . .

CARAVAGGIO. There is . . . dedication! The oath of the painter
that nothing, nothing will come between his canvas and
himself! [*He laughs.*] Luck!

PRINCE. If you'll permit me to speak, I'll expl . . .

CARAVAGGIO. There is . . . [*The* PRINCE *gestures in exaspera-
tion.* CARAVAGGIO *pays no attention.*] . . . a way of seeing.
As if the painter had sailed like Columbus into a new
world of his own creation!

DEL MONTE. And, there is a little luck in finding a patron who
will feed you and shelter you while you paint. Yes, and
clothe you. Now, Michaelangelo, our guests will be here
shortly. I want you to take off those rags of yours . . .

CARAVAGGIO. My clothes? These are my only . . .

DEL MONTE. I'm well aware of that. We have plenty of tunics
freshly laundered. [*To the* PRINCE.] They are like the ones
the Greek nymphs used to wear.

CARAVAGGIO. I don't wear tunics.

PRINCE. And the sashes, so much more becoming than on
women.
[*To* CARAVAGGIO.] Put on a sash.

CARAVAGGIO. I don't wear sashes!

DEL MONTE. You wear what I tell you to wear! I want you
dressed as all my servants are dressed.

CARAVAGGIO [*explosively*]. But . . . I'm not a servant! I'm a
painter!

DEL MONTE. Do you wish to return to where I found you? . . .
Do you? [*He snaps his fingers.*] Ambrogio! Take him away
and see that he is decently dressed.

[AMBROGIO *takes* CARAVAGGIO'*s hand. After a moment of near-defiance, he lets himself be led away.*

PRINCE. Of all the ill-bred, arrogant . . .

DEL MONTE. Ill-bred, yes . . .

PRINCE. . . . Deserves a good thrashing! . . .

DEL MONTE. . . . and arrogant as all great artists are arrogant. Think of the popes who made emperors crawl before them. They crawled in turn to get what they wanted in art.

PRINCE. And you condone that?

DEL MONTE. They knew what they were doing. There is no better way than the arts to impress upon the faithful the glories of God . . . and of those who do His work.

PRINCE. But . . . crawling! . . .

DEL MONTE. Oh, I grant you the Holy Fathers tried bribes and threats to begin with. But if those failed to work . . . great artists are a queer breed. They set their own terms, and you pay their terms, ill-mannered and arrogant though they may be.

PRINCE. So . . . good manners count for nothing then! And blood! Is noble blood of no importance?

DEL MONTE. In art? Some drunken lout will throw a peasant girl upon a haystack sweating and grunting like a sow in heat. And from their disgusting orgy there will rise a lad whose visions in their radiance will blind us all.

PRINCE. Well! In his origins at least he'll qualify. But I beg you, keep him out of sight. No matter how you dress him, he'll never look like these.

DEL MONTE. I hope not! He who is beautiful in himself has no need to search further for beauty; which is why most artists are ugly.

PRINCE. My dear Francesco, be careful; you're becoming profound!

DEL MONTE. No, no, it's very simple. You move in the midst of
beauty and you cease to observe it. It takes an urchin with
his nose pressed against the palace window to marvel at
the beauty of all that he sees within.

[*As* DEL MONTE *is speaking,* CARAVAGGIO *and* AMBROGIO
return. AMBROGIO *takes his place among the musicians.*
CARAVAGGIO *stands by himself in his humiliation; trapped,
isolated, enraged, ashamed. He grips his tunic as if he is about
to tear it off his chest. He glances around as if may rush out of
the palace at any moment. No one is aware of him.*]

PRINCE. That's profound! I insist! [*To the musicians.*] Your
master is being profound!

DEL MONTE. Their protector, shall we say . . . their loving pa-
tron. And now . . . Andrea . . . our guests will be here
shortly . . . so one song if you will, just for us. [ANDREA
strikes a few chords.]

CARAVAGGIO [*in a furious whisper*]. How can you sing for
them?

ANDREA [*a languid shrug as he plucks the lute*]. For them . . .
for you . . . for anyone who pays me.

CARAVAGGIO. Whores! . . . All of you! . . .

[*He stands, enraged.* ANDREA, *shrugging his shoulders,
starts to sing one of the* frottoles *of Trombocino. As he sings,*
CARAVAGGIO'*s mood slowly changes. He hears the song; he
listens to it. He turns reluctantly and like* DEL MONTE, *is en-
chanted by the song and its setting. Unnoticed by all others,
he moves around the musicians until he finds the viewpoint
that he wants.*]

ANDREA. Since by love I'm overpowered
 Do not tell me I'm to blame.
 Since by love I'm overpowered
 Do not tell me I'm to blame.

I'm the kindling, not the flame.
Pity me who am devoured
Since by love I'm overpowered,
Do not tell me I'm to blame.
Pity me who am devoured.
I'm the kindling, not the flame,
Do not tell me I'm to blame.

PRINCE. Bravo! . . . Bravo!

[*The following lines of the* PRINCE *and* CARAVAGGIO *are spoken simultaneously.*]

PRINCE. Oh, he's excellent. But excellent! My dear Del Monte! What a treasure! No wonder Rospigliosi was furious when you stole him! . . . Wicked man!

CARAVAGGIO. What are you stopping for? . . . Don't stop . . . Go on . . . Go on! . . .

ANDREA. Since I've struggled with this sickness
'Til my strength is all but gone.
Since I've struggled with this sickness
'Til my strength is all but gone,
My surrender is no wrong.
Do not scorn me for my weakness
Since I've struggled with this sickness
'Til my strength is all but gone
Do not scorn me for my weakness.
My surrender is no wrong
Since my strength is all but gone.

[*The lights begin dimming during the second verse, so that by its end only the musicians are seen.*]

Act I

SCENE II

[*Light rises first on* CARAVAGGIO's *painting,* The Musicians. *The Cardinal is writing in his study. His desk is covered with documents. He seems weighed down by his responsibilities.*

FATHER FIRMO, *a priest from the provinces who has been granted an audience, waits. As he waits, he examines the painting hung on one wall.*]

DEL MONTE [*without looking up*]. You like it?

FATHER FIRMO. Your Eminence? . . . oh . . . of course!

DEL MONTE. It's not for sale.

FATHER FIRMO. Oh! Your Eminence is joking. Even I know its value. I . . .

[DEL MONTE *is writing and not listening.* FATHER FIRMO *watches* DEL MONTE's *pen and attempts to speak when it pauses. It scratches on. At last* DEL MONTE *lays down the pen*

*and shakes his head to clear it. He gestures, still without look-
ing up.*]

DEL MONTE. Now, Father.

FATHER FIRMO. Father Firmo, Your Eminence, from Lombardy.

DEL MONTE. Well Father Firmo?

FATHER FIRMO. Your Eminence is busy, I know, and I am just a
country priest. So I would like first to thank Your Emi-
nence for . . .

DEL MONTE. You've come to support the claims of Father Filip-
po. We're working on it, Father, we're working on it. But
you can't become a Saint overnight.

FATHER FIRMO. Excuse me, Your Eminence. I pray, of course,
that Father Filippo may be beatified; but that is . . .

DEL MONTE [*writing*]. You have a candidate for the seminary,
some devout young lad.

FATHER FIRMO. Ah no, Your Eminence, . . . I've come about . . .
your painter.

DEL MONTE. You have a commission [*He sighs.*] My dear
Father, you see this sheaf of papers? Every one is from a
bishop, a banker, a secretary of some order or other, bid-
ding for Caravaggio. He's booked up for years ahead!

FATHER FIRMO. Ah!

DEL MONTE. There's been no limit to it, since the Contarelli
Chapel was opened. [*Back at his work.*] You've seen his
altarpiece there, I suppose.

FATHER FIRMO. Ah yes! Along with hundreds of others, I . . .

DEL MONTE. The whole of Europe is parading through that
place! Pushing, shoving . . .

FATHER FIRMO. And arguing, Your Eminence. There are those
who argue that Caravaggio's paintings are . . . lacking in

decorum. Do their opinions concern Your Eminence? . . .

DEL MONTE. As much as the opinions of the old women who sell roasted chestnuts out there in the Piazza. My dear Father, a Prince of the Church does not consult the populace for opinions on art.

FATHER FIRMO. There are those . . . who whisper that the paintings . . . smack of heresy.

DEL MONTE [*writing*]. And rightly Father; they are right.

FATHER FIRMO. You are not serious!

DEL MONTE. Oh yes. [*Smiling.*] But then, as you know, Cardinals need not worry too much about being accused of heresy. That is one of the pleasures of being a cardinal.

FATHER FIRMO. Well, you must be very proud to be the patron of such a famous painter.

DEL MONTE [*writing*]. Proud and harassed, Father, proud and harassed.

FATHER FIRMO. I too am proud. You see, Your Eminence, I am his earliest patron, so to speak.

DEL MONTE [*writing*]. Very commendable, Father.

FATHER FIRMO. You might say that I am the one who started him on his career, by placing him with the painter, Peterzano. I am his brother!

DEL MONTE [*barely listening*]. Peterzano's?

FATHER FIRMO. Michaelangelo's. I am Firmo Merisi.

DEL MONTE. His brother. [*He stops writing.*] He never told me that he had a brother.

FATHER FIRMO. Oh yes! And a sister. Celestina never married, and so she acts as my housekeeper. That way we save money. The Bishop says . . .

DEL MONTE. Yes . . . Well . . . you've come a long way to see your brother and he'll certainly want to see you.

[*He rings a bell and a* PAGE *enters.*] Ask Caravaggio to come in, if he will.

[PAGE *exits.*] Now Father, if you'll excuse me. [*He writes a line or two and pauses.*] It is strange that he never mentioned you. Are you sure you are his brother?

FATHER FIRMO. But . . . of course, Your Eminence! We two are the sons of Firmo the Elder, may his soul rest in peace.

DEL MONTE [*writing*]. He never mentioned it.

FATHER FIRMO. There were other children too, born to our beloved mother; may God and the Blessed Virgin grant them all eternal rest.

DEL MONTE. Amen.

FATHER FIRMO. I was five years older than Michaelangelo. So I had charge of him. I dressed him for communion; I led him to confession. I dragged him, you might say, for it was no easy task, Your Eminence, believe me! Yes indeed! Making Michaelangelo confess his sins was like . . .

[*The* PAGE *enters.* DEL MONTE *turns to him.*] . . . like making a donkey . . .

DEL MONTE. Well?

PAGE. He said . . . that he was working . . . [*Pause.*]

DEL MONTE. Did he? . . . Well . . . If he will not come to us . . . we must go to him. [*As he puts his papers away.*] I think that I should warn you, Father . . . you may find that your younger brother . . . has changed . . .

Act I

Scene III

[CARAVAGGIO's *studio in the palace.* LENA *stands on a platform as she may be seen in* CARAVAGGIO's *painting,* The Madonna of Loreto. *She holds a stuffed bundle—the infant—in her arms.* CARAVAGGIO *works on the painting. He wears velvet, which from now on will become shabbier. He has a dark moustache and goatee.*]

LENA. My arm . . . it's aching . . . [*Pause.*]

CARAVAGGIO. Let it ache.

LENA. My neck . . . it is killing me! [*Pause.*]

CARAVAGGIO. You'll live.

LENA. My shoulder . . . how much longer? [*No response.*
 At last,* CARAVAGGIO *lays down his palette, exhausted. He nods. He starts to clean his brushes. She lays down the bundle; she stretches and sighs.*]
 It's not easy . . . being the Virgin . . . Still . . . [*She rubs*

her neck.] Compared to the laundry ... [*She rubs her arms; she strokes the velvet sleeves.*] Velvet ... I love the feel of velvet ... makes me feel rich ... I never wore velvet before ... nor a satin cape ... nor a scarf of silk like this one ... nor gold braid in my hair ...

[*She saunters around to look at the painting.*] Beautiful ... She's beautiful ... [*She glances in the mirror.*] But ... she's not me ...

CARAVAGGIO. Shut your mouth.

LENA. My hair, yes ... my chin ... my nose maybe ... but ... the rest ...

CARAVAGGIO. Shut your mouth! You know nothing!

LENA. I know myself! [*She glances in the mirror and turns back to the painting.*] Those eyebrows ... hours, she must have spent on them ... That skin! Well born, she is ... and that's Our Lady ... not like the rest of us ... if she was, we wouldn't pray to her ... No, ... she never had to work for a living ...

CARAVAGGIO. She worked.

LENA. With that skin? ... With those fingers? [*She looks at her own hands. A knock on the door.*] Rough and red, my hands are! ... Look, just look at them! And my arms ... thick and hard ... feel them, just feel them! ... That's what working does! [*The knocking continues.*]

CARAVAGGIO. I'm working! ... Back where you were! ... Head down ... and tilted ... further.

LENA. I'm trembling!

CARAVAGGIO. Be still! [*The door opens.* DEL MONTE *stands there.* LENA *motions.* CARAVAGGIO *turns his painting to the wall.* DEL MONTE, FATHER FIRMO *and the* PAGE *enter the room.*]

I said I was ... [*He sees* FATHER FIRMO *and stops short. A long pause.* LENA *sits in a corner.*]

DEL MONTE. Well?

FATHER FIRMO. Well! Michele! . . . How you've grown! My word yes! . . . If we held a wrestling match today, I don't suppose I could throw you the way I used to do! . . . And that moustache and beard too! Well, almost a beard . . . I declare, Michele, I might not have recongized you, if His Eminence hadn't . . .

CARAVAGGIO [*to* DEL MONTE]. Who is he?

DEL MONTE. Who is he? . . . He's your brother . . .

CARAVAGGIO. I have no brother.

> [*The following lines are spoken simultaneously.*]
DEL MONTE. No brother?
FATHER FIRMO. No brother!
> [*They wait;* CARAVAGGIO *shakes his head.*]

FATHER FIRMO. But . . . Firmo was our father . . . Firmo, the master-builder. And Anna-Maria, his wife, was our beloved mother . . . And Celestina, the devout Celestina is our sister and I . . . I am your brother, flesh of your flesh; blood of your blood!
> [*He waits and sees no recognition. He moves close to* CARAVAGGIO *and speaks in a low voice.*] Michele! I forbid you to deny me, in the presence of His Eminence. I . . .
> [*To* DEL MONTE.] He . . .
> [*To* CARAVAGGIO.] You can't deny me!

CARAVAGGIO. I can and I do.

FATHER FIRMO. Your Eminence . . .

DEL MONTE [*To* CARAVAGGIO]. Are you telling us that . . .

CARAVAGGIO. Us! Why must you take his side?

FATHER FIRMO. Do you, do you dare to address His . . .

DEL MONTE [*brushing* FATHER FIRMO *aside*]. Very well, *me!* Are you telling me to call my fellow priest a liar? . . . Are you? . . . Then listen to me Michaelangelo . . . Listen to me! . . .

You were a ragged urchin when I took you in. And now . . . your name, your reputation, the fine clothes you're wearing . . . I . . . I made you what you are!

CARAVAGGIO. For your own good reasons!

FATHER FIRMO. How dare you . . .

DEL MONTE. I fed you. I housed you. I secured the Contarelli commission . . .

CARAVAGGIO. And *I,I* filled the Chapel with *my* paintings!

DEL MONTE. I defended your paintings against charges of Protestantism. It wasn't easy! I've made a dozen enemies because of you. And now . . . do you think you make a fool of me, here, in my own Palace? . . . Well? . . . Answer me!
[*A pause.* CARAVAGGIO *is silent.*]

FATHER FIRMO. He was always the same; stubborn . . . stubborn
. . .
[*To* CARAVAGGIO.] You broke our poor mother's heart with your stubbornness!

CARAVAGGIO. I did not!

FATHER FIRMO. Broke her poor heart! She who adored you!

CARAVAGGIO. A lie! She alone . . .

FATHER FIRMO. Everyone in our village knew it! And condemned you for it!

CARAVAGGIO. Fools, all of them; hypocrites, like you!

FATHER FIRMO. You came from us!

CARAVAGGIO. And left you!

FATHER FIRMO. Yet you took on the name of our village!

CARAVAGGIO. I am what I am! [*Pause.*]

DEL MONTE. Well . . . at least you admit that he's your brother!

CARAVAGGIO [*after a pause*]. I had a brother.

DEL MONTE. That's better! Now you . . .

FATHER FIRMO. Now you betray him!

CARAVAGGIO. Betray him? I . . . I was betrayed!

> [*The following lines are spoken simultaneously.*]
FATHER FIRMO. Betrayed! Is that the thanks I get . . .
DEL MONTE. Betrayed! Who are you to stand in judgment on
your brother? *Judge not lest ye* . . .

CARAVAGGIO [*To* DEL MONTE]. And who are you to stand in
judgment on me?

> [*The following lines are spoken simultaneously.*]
FATHER FIRMO. What! Do you dare to speak to His Eminence in
. . . in words of such gross . . .
DEL MONTE. You presume too far, Michaelangelo; you try my
patience too far!

> [*The following lines by* CARAVAGGIO, FATHER FIRMO
and DEL MONTE *are spoken simultaneously.*]
CARAVAGGIO [*To* DEL MONTE]. Were you cast out of your own
home as I was? Were you left with your new owner to be
treated as a dog? Have you eaten garbage out of garbage
bins? Have you been carried in a cart to a pauper's hospi-
tal? Covered with lice? Left for dead?
FATHER FIRMO. . . . Lies! . . . Base lies! . . . I beg your Lordship!
. . . I implore you! Silence him! . . . Forbid him to speak!
. . .
DEL MONTE. No sense of obligation. No respect. Not for your
patron; nor even for your family! . . . No. Let him finish!
Give him rope and let him hang himself. . . .

DEL MONTE. And look at you now!

FATHER FIRMO. Putting on airs, as if you were Raphael!

CARAVAGGIO. I spit on Raphael!

FATHER FIRMO. Think you're as great as the great Michaelan-
gelo!

CARAVAGGIO. I am!

FATHER FIRMO. Boaster! You were always a boaster!

CARAVAGGIO. I had reason to boast! That was why you hated me!

FATHER FIRMO. You are speaking to a priest! Remember that!

CARAVAGGIO. A priest! I paid a high price for becoming what I am! And what did you pay? You, with your fat hands, folded across your belly! Clothed by the Church, fed by the Church . . .

DEL MONTE. As you are fed!

[*The following lines by* CARAVAGGIO, FATHER FIRMO and DEL MONTE are spoken simultaneously.]

CARAVAGGIO [*To* FATHER FIRMO]. You found a warm bed for yourself, while I lay out in the streets! For years! And then you hear that the brother you abandoned is living in a Cardinal's palace. You smell something cooking for yourself in that kitchen! So you head for Rome! You say: "I am the brother of the famous painter, Caravaggio! I am his earliest patron, so to speak." That way, you think, you'll advance yourself through me! Oh no! Oh no!

FATHER FIRMO. . . . Insolence! . . . Ingratitude! For years I slaved! Worked my hands to the bone! and now! Look at the thanks I get! As if I'd committed some sin! . . . A dog, a cat would be more grateful. A pig would be more grateful than you are! . . .

DEL MONTE. But, can you admit it? You can never admit that you owe anything to anyone! You turn against those who try to help you. It's as if you wished to destroy yourself and all around you . . . even those who most respect you . . . Ah! It's no use, no use! I've done all that I can. I wash my hands of you . . .

[*Pause.*]

FATHER FIRMO. Your Illustrious Lordship . . . if I had known . . .

DEL MONTE. You had no way of knowing.

FATHER FIRMO. These lying insinuations which he seeks to lay on my conscience; as God is my witness; as Almighty God is my witness, I deny them! And I disown . . .

DEL MONTE. Be careful. Remember . . .

FATHER FIRMO. I disown him as he disowns . . .

DEL MONTE. . . . that you are a priest.

FATHER FIRMO. I . . . [DEL MONTE *motions to him to leave.*] . . . You're right . . . of course . . . I am a priest . . . with a priest's duty to fulfill. [*At the door.*] I came a long way, brother; a long way just to see you. I had heard so much . . .

CARAVAGGIO. That was why you came!

FATHER FIRMO. Why must you . . . [DEL MONTE *checks him with a motion.*] It's true . . . it's true that I took pride in your success. If I was unduly proud, then God has humbled me. Yes, God has humbled me; Your Eminence is a witness to that. But . . . there was another reason . . . another reason for my journey. I had hoped . . . I had hoped that with God's help I might arrange a marriage . . .

CARAVAGGIO. A marriage! [*He looks at the* PAGE. *They burst out laughing.*]

FATHER FIRMO. Some girl from our town . . . of good, sturdy stock. [*More laughter.*] A marriage that God, in His infinite goodness, might bless with children, so that the name of Merisi might . . .

CARAVAGGIO. Then marry yourself! Or fill the belly of your housekeeper, if that's the way you want to keep the name of Merisi alive!

FATHER FIRMO. Ah! . . .

CARAVAGGIO. I have other ways.

FATHER FIRMO. The ways of the . . .

[DEL MONTE *holds out his ring finger. After a moment,* FATHER FIRMO *realizes that he has been dismissed. He kneels and kisses the ring.*] Your Eminence, . . . I will never forget your kindness . . . I shall tell the Bishop . . .

[DEL MONTE *dismisses him. He starts out and returns to* CARAVAGGIO.] I shall pray for you. I shall pray to the Blessed Virgin to intercede for you. And I know that Celestina will do the same. In her chaste and virginal prayers! [*He goes out.*]

CARAVAGGIO. You'll pray for me! [*He runs to the doorway and shouts.*] Did you ever really pray for anyone? Did you ever empty your guts out into a prayer? [*Pause.*]

DEL MONTE. Why did you deny him?

CARAVAGGIO. He, he denied me! Can't you see that!

DEL MONTE. I see pride; stubborn pride.

CARAVAGGIO. Was he his brother's keeper? You know where you found me.

DEL MONTE. I know.

CARAVAGGIO. Yet you don't know me. No one knows me.

DEL MONTE. And you know no one.

CARAVAGGIO. I am alone.

DEL MONTE. Never willing to admit that you stand in need of God's mercy and forgiveness. Never able to admit that you need your fellow men.

CARAVAGGIO. I have always been alone.

DEL MONTE. Never able to admit your errors. Never willing to acknowledge your debts.

CARAVAGGIO. When I said . . . that I was the one who filled the Contarelli Chapel . . . [DEL MONTE *waits.*]

DEL MONTE. Never considerate; never content. Always battering your head against one wall or another. Why? Why?

CARAVAGGIO. I'm . . . possessed.

DEL MONTE. I thought I could civilize you. I was mistaken.

CARAVAGGIO. You no longer want me in your household. Is that it? You want me to leave.

DEL MONTE. When you are ready. [*He moves to the door.*]

CARAVAGGIO. I am ready! Now! I can stand on my own! And, if I choose to live in a palace, there are a dozen princes who will take me in!

DEL MONTE. Good! Then take your pick among them.

CARAVAGGIO. I will! In them and in all things!
 [*He seizes the* PAGE.] Come with me! [*The* PAGE *struggles to escape.*] "Where you go, I go." You said that!
 [*The* PAGE *breaks away and runs to* DEL MONTE.]

DEL MONTE. The boy stays with me. [*He and the* PAGE *leave, closing the door.* CARAVAGGIO *stands for a moment, then rushes to the door and pounds upon it.*]

CARAVAGGIO. And my paintings! What about my paintings!
 [*The door opens.* DEL MONTE *stands there.*]

DEL MONTE. *My* paintings. I'll take good care of my paintings.
 [*He closes the door.*]

CARAVAGGIO. You! You'll take good care, of *your* paintings!
 [*Spreadeagled against the door for one moment, as he pounds upon it.*] And what about the painter; the one who tore himself to shreds to paint them? Who will care for him? [*Pause.*]

LENA. I will.
 [*No response from* CARAVAGGIO, *slumped on his stool.* LENA *rises. As she talks, she takes off the gold braid, the cape, the scarf, the velvet dress. Over her own rough shift, she puts on her own dress of rough red cloth.*]
 There's a room in the house where I live . . . It's on the Piazza, just past Teofilo's . . . It's as big a room as this one

... with a window to paint by ... and a cupboard for your junk ... [*No response from* CARAVAGGIO.] The rent ... [*A gesture of rejection.* LENA *folds or hangs up the dress, the cape, the scarf.*]

Well ... we won't be needing these ... [*She gathers up her own belongings.*] You think that because you're famous, because you pay me for standing still, while you're painting me ... well ... I was listening through all that ... I heard what you said. About eating garbage, sleeping in the streets. And I heard what His Eminence said about the time he found you. An urchin, he said you were, a ragged urchin, when he took you in. [*A gesture: get out! from* CARAVAGGIO.]

Well? ... What's so bad about that? ... [*She starts to leave and pauses.*] "I am what I am." You said that. And it is true. For all of us. You and me and most of Rome ... we're all urchins ... we'll always be urchins to them. [*She watches him.*]

Michele? ...

Act I

Scene IV

[*By the Tavern of the Moor: 1604.*
CARAVAGGIO, LENA, TRISEGNI *and* LONGO *sit celebrating at night at a table outside the tavern. A street lamp hangs or stands at the far side of the stage.*]

CARAVAGGIO [*shouting*]. Pietro!

TRISEGNI *and* LONGO. Pietro! . . . Pietro! [*A slovenly waiter appears.*]

PIETRO. Well?

CARAVAGGIO. Well! You haven't even cleared our table!

PIETRO. You don't have to shout. [*He begins to clear the table, scraping the remains of food from one plate to another and brushing the breadcrumbs onto the ground.*] I'm not deaf you know. [*He picks up a half-empty glass of wine and drinks it, taking his time.*]

CARAVAGGIO [*with good humor*]. You scoundrel! Now what are you doing?

PIETRO. Drinking what's mine.

TRISEGNI. Yours! It's not yours!

PIETRO. No? Whose is it then? Eh? [*He continues to clear the table.*] Don't you even know you're supposed to leave some wine in your glass?

TRISEGNI. But not for you.

PIETRO. For who then? [*He picks up another glass.*] What do you think us waiters live on—the tips you give us? [*He drains the glass.*] A gentleman never finishes his wine.

CARAVAGGIO. No, he leaves the dregs for we others to swallow!

PIETRO. And you—you drink the dregs! [*He goes out with the plates and glasses.*]

CARAVAGGIO. Now . . . Tell me what happened!

LONGO. You should have been there to see your altarpiece unveiled!

CARAVAGGIO. You, you were the one who warned me to keep away! [*With affection.*] And you were right. One jibe from my enemies, and . . .[*He picks up a knife and strikes the table top.*] So, tell me.

LONGO. People came by the thousands.

TRISEGNI. The priests were half crazy trying to keep the crowds in line! [PIETRO *returns.*]

LONGO. All the ambassadors were there. And all the Academy.

TRISEGNI. The great Zuccari!

LONGO. The Cavaliere D'Arpino.

TRISEGNI. The noble Baglione.

PIETRO. Well?

LENA. And don't forget my family. They were there.

PIETRO. Well? What's it to be?

TRISEGNI. They were there all right! Her little brother kept pointing up to the painting and crying out: "That one, with the baby; that's my sister!"

LENA. Everyone stared at me. As if I really was Our Lady.

CARAVAGGIO. You see! I made you famous!

LENA. Yes, and how many loaves of bread will that buy me?

CARAVAGGIO. Enough.

PIETRO. Well?

CARAVAGGIO. Eat any more, you'll look as if you're pregnant.

LENA. Don't worry!

CARAVAGGIO. I'd have to paint you as the Pregnant Virgin.

LENA. And didn't she get pregnant?

TRISEGNI. Not the way you would.

LENA. How then? The pigeon?

LONGO. Careful! Now that you're up there, above the altar!

LENA. Was she careful?

TRISEGNI. At least she knew who the father was.

LENA [*to* CARAVAGGIO]. I'd know who it wasn't! [*No response.*]

PIETRO. You shout for me to come, and when I come, you pay no attention! . . . Now! . . . What's it to be?

LONGO. The usual . . . with plenty of sauce.

PIETRO. The usual . . . And yours? [LENA *shakes her head.* PIETRO *turns to* TRISEGNI.]

TRISEGNI. The veal.

PIETRO. The veal! A la Marsala? A la Bologna?

TRISEGNI. "A la Marsala, a la Bologna!" You villain, you know as well as I do that it all comes out of one tub!

PIETRO. One veal. And yours?

CARAVAGGIO. The artichokes.
 [*To* LONGO.] Did the Cardinal come?

LONGO. Three cardinals came.

TRISEGNI. And a dozen princes, all with their . . .
 [*To* PIETRO.] Well? What are you waiting for?

PIETRO [*To* CARAVAGGIO]. How many?

CARAVAGGIO [*grandly*]. Twenty-four!

PIETRO. Twenty-four! Then go and dig them! We don't have
 that many in the kitchen!

CARAVAGGIO. As many as you have then.
 [*To* LONGO.] Three cardinals; a dozen princes!

PIETRO. Eight.

CARAVAGGIO. Baglione must have burned to ashes with envy!

PIETRO. There are eight.

LONGO. Oh, he was envious! He . . .

PIETRO. There are eight artichokes! Eight!

CARAVAGGIO. Well? Eight then! . . . And what did he do?

TRISEGNI. He stopped everyone he could and . . . [LONGO *checks
 him with a warning signal.*]

CARAVAGGIO [*to* TRISEGNI]. Well?

PIETRO. How do you want them?

CARAVAGGIO [*to* TRISEGNI]. Go on!

PIETRO. A la Romagna? a la Guidecca? [*He sighs.*] Cooked in
 butter or cooked in oil?

CARAVAGGIO. Half and half. Now . . .
 [*To* TRISEGNI.] Tell me what he said!

PIETRO. Half in butter, half in oil. [*He goes out.*]

LONGO. He stopped everyone who would listen. He told them the painting was . . .

TRISEGNI. Vulgar.

CARAVAGGIO. Vulgar! . . . He called my altarpiece vulgar! . . . Well! . . . The two of you must have put a stop to that!

[BAGLIONE *approaches. He carries a lap dog, and is followed by a* PAGE.]

[*The following lines are spoken simultaneously.*]
LONGO. The two of us . . .
TRISEGNI. What could we do? . . .

CARAVAGGIO. You mean you did nothing? You let him . . .

TRISEGNI. Hush! Here's Baglione now! [CARAVAGGIO *reaches for his sword.* LONGO *grips his arm.*]

LONGO. Easy!

TRISEGNI [*reciting*]. "Gian Bagaglia, broken-hearted, tried to paint and only . . ."

CARAVAGGIO. Quiet; I have a better idea! [*He buckles on his sword. He crams his hat down over his head and saunters out to confront* BAGLIONE. *Alarmed,* BAGLIONE *hands the dog to his* PAGE.]
 Sir!

BAGLIONE. Sir?

CARAVAGGIO. You are well met!

BAGLIONE. And you sir.

CARAVAGGIO. Do you know me?

BAGLIONE. I know you.

CARAVAGGIO. Well then!

BAGLIONE. Well?

CARAVAGGIO [*touching his hat*]. I am waiting.

BAGLIONE [*motioning to* CARAVAGGIO's *hat*]. And I . . . I am waiting.

CARAVAGGIO. Sir?

BAGLIONE. Sir!

CARAVAGGIO. Will you not doff your hat to me?

BAGLIONE. Only if you doff your hat to me!

CARAVAGGIO. You must doff yours first!

BAGLIONE. No, you must doff yours first!

CARAVAGGIO. Sir!

BAGLIONE. I come from a noble house!

CARAVAGGIO. I, from the gutter!

BAGLIONE. I belong to the Academy.

CARAVAGGIO [*smiling*]. I piss on the Academy!

BAGLIONE. I hold the rank!

CARAVAGGIO. I hold the nose!

BAGLIONE. The nose?

CARAVAGGIO [*reaching forward and giving* BAGLIONE's *nose a slight tweak*]. The nose.

BAGLIONE [*appalled, and trying to pass*]. Sir!
CARAVAGGIO [*blocking the way*]. Sir?

BAGLIONE [*faintly*]. My blood is finer.

CARAVAGGIO [*imitating him*]. My cock is stiffer!

BAGLIONE. I am known to His Excellency!

CARAVAGGIO. And I to his scullery maid!

BAGLIONE [*bent upon passing*]. I have my supporters!

CARAVAGGIO [*his hand on his sword*]. And I my sword! [*A pause;* BAGILONE *surrenders.*]

BAGLIONE [*in a whisper*]. May the rope stretch you!

CARAVAGGIO [*in a mocking whisper*]. May the pox devour you!

BAGLIONE [*doffing his hat with the meanest of gestures*]. Sir!

CARAVAGGIO [*sweeping his hat off and bowing low*]. Sir!

BAGLIONE [*as he hurries off*]. An outrage! When His Excellency hears of this, . . .

CARAVAGGIO [*shouting after him*]. He'll clap me in the Tor di Nona, is that what you want?
 [CARAVAGGIO *returns to the table where the others sit laughing. He sits down.*] Now . . . tell me what Zuccari said.

LONGO. Well . . . he . . .

TRISEGNI. No! It's my turn! I'll show you what he said! [*He stands, looking upward, as if at the altarpiece. He speaks in an aged, falsetto voice.*] He said: "I'll admit that the fellow can paint . . ."

CARAVAGGIO. At last, he admits it!

TRISEGNI. "But, I ask myself," he said, "has it that indefinable spirit, that we painters draw, as if it were from the very air that surrounds our Blessed Lady? Is it, in a word, uplifting? Or is it lacking in decorum?"

CARAVAGGIO. Lacking in decorum! Well, he can have his decorum! He can have the stuffed doll that he calls our Blessed Lady! And all the little dolls that he places around her: his martyred saints, with their fingernails so nicely polished, and every golden curl in its proper place!
 [*He spits.*] . . . Go on!

TRISEGNI. Well . . . D'Arpino, as we said, was there . . .

LONGO. And, of course, he chimed in. [*He rises and speaks in a*

mannered voice.] He said: "Observe! The plaster is peeling off the wall of Our Lady's house!"

TRISEGNI. "Most indecorous!" cried Zuccari. "And observe the bare feet of the pilgrims, they're filthy!"

LONGO. "God, the Father!" cried D'Arpino. "Where is He in this painting?"

TRISEGNI. "Where indeed!" cried Zuccari. "If this painter were a true Christian . . . "

CARAVAGGIO. A true Christian! and they are true Christians because they paint the Almighty flapping around like a stuffed owl in the sky!

LONGO. Easy . . . Easy! . . . Listen Michaelangelo . . . they're jealous, that's all. They're sick with envy in the presence of a masterpiece.

CARAVAGGIO. You believe that?

LONGO. I believe that you will be revered when those two are long forgotten. I believe that if we are remembered it will be because we were your friends.

CARAVAGGIO. You say that because you are my friend. I believe it because I must . . . Oh, damn them, damn them! . . . And damn the two of you for . . .

LONGO and TRISEGNI. The two of us!

CARAVAGGIO. For not fighting back!
[PIETRO *enters with the food. The following lines are spoken simultaneously.*]
LONGO. If we could have stopped them . . .
TRISEGNI. You want us to be arrested?

PIETRO. One of the usual.

CARAVAGGIO. Call yourselves my friends!

LENA. They are your friends.

LONGO. Your only friends.

PIETRO. One veal.

CARAVAGGIO. Then stand up for me!

PIETRO. Eight artichokes.

TRISEGNI. How?

PIETRO. Four . . .

CARAVAGGIO. You should have drawn your swords against them!

LONGO. In the chapel?

PIETRO. Four cooked in . . .

CARAVAGGIO. You should have driven them from the chapel!

TRISEGNI. And ended up in prison!

PIETRO. Four . . .

CARAVAGGIO. Yes! If need be!

PIETRO [*forcing his way between them*]. Four cooked in butter, four in oil.

CARAVAGGIO. And which are which?

PIETRO [*sighs*]. How should I know?

CARAVAGGIO. How should you know? You brought them!

PIETRO. I brought them, yes! But I didn't cook them. I didn't take one and put it in a pan of butter and another and put it in a pan of . . .

CARAVAGGIO. How am I to know then?

PIETRO. Smell them. Smell them and then you will easily tell which is cooked in butter and which in oil.

CARAVAGGIO. You're the waiter! You're supposed to . . .

PIETRO. Very well; if you insist. [*He picks up an artichoke and holds it against his nose.*] This one, this one smells of butter.

[*He puts it back on the plate and picks up another.*] And this one; this one also smells of butter. [*He puts it back and licks his fingers.*]

CARAVAGGIO. Go on! Smell the rest!

PIETRO. Since you insist . . . [*He picks up a third, and holds it to his nose.*] Ah! Here is one that smells of oil. Definitely! This one smells of . . .

CARAVAGGIO. Of your filthy hands!
[CARAVAGGIO *grabs the remaining artichokes and standing, crushes them into* PIETRO's *face.*] You scoundrel! You eat them, now that you've ruined them!

PIETRO. Help . . . help me! . . .

CARAVAGGIO. I may not be a cavalier, but I'll be damned if I'll be treated like a tramp!

LONGO [*as he and* TRISEGNI *rise to pull* CARAVAGGIO *off the fallen* PIETRO.] Easy, for God's sake! . . . Easy!

[*The following lines by are spoken simultaneously.*]
CARAVAGGIO. I'll show you who's a tramp! I'll teach you manners!
PIETRO. Help!. . . I can't breathe! He's choking me! . . .

TRISEGNI. Let him go, you fool! . . . You'll kill him!
VOICE OFFSTAGE. It's Pietro! . . . He's killing him!

[*From this moment on, everyone speaks at once, until the abrupt ending of the scene.*]

CARAVAGGIO. I'll . . . Let me go! . . . Call yourselves my friends! . . . Just because I'm . . . He thinks he can . . . A painter, I tell you . . . A great painter! . . . Nobody . . . nobody is . . . going . . . to mock me! . . .

PIETRO. I'm blinded . . . Can't see . . . He . . . told me to . . . Just trying to oblige, that's all . . . Would have killed me . . . Tried to kill me . . . police . . . in prison, that's where he . . .

LONGO. For God's sake, Michaelangelo . . . Calm yourself! . . .
Think of your work! . . . You can't afford . . . They'll put
you in prison again . . . in prison . . .

TRISEGNI. Always in trouble! . . . Never know when to stop! . . .
A joke's a joke, but you . . . Land us all in prison, before you
. . .

LENA. Please Michele! . . . Not again! If you go back to prison
. . . what's to become of me?

VOICES OFFSTAGE. Pietro's killing who? . . . No, no! . . . The
painter! . . . He's killing . . . Quick . . . Call the police be-
fore he . . . Help! Police!

[*Stage blacks out.*]

Act I

[*In the Court of the Governor of Rome, 1604-5.*
CARAVAGGIO *stands in the prisoners' box. He is beginning
to look haggard and his suit is shabby. The* MAGISTRATE *looks
down from his bench and takes notes.* BAGLIONE *dressed in the
manner of a cavalier, is on the witness stand.* LENA, LONGO,
and TRISEGNI *stand in a corner behind a guard.*]

MAGISTRATE [*writing*]. Name and residence.

BAGLIONE. Giovanni Baglione. Roman.

MAGISTRATE. Profession.

BAGLIONE. Painter. Member of the Academy of Saint . . .

MAGISTRATE. Complaint.

BAGLIONE. Well, Your Excellency, it's like this: I'd painted a
picture of Our Lord's Resurrection for the Society of Jesus.
It was a very fine commission. And Merisi was after that
commission too . . .

CARAVAGGIO. Ah!

BAGLIONE. So, naturally, he was envious of me . . .

CARAVAGGIO. I, envious of you! I . . .

BAGLIONE. He was envious. And when my painting was un-
veiled, on Easter Sunday he handed out slanderous verses
about me.

MAGISTRATE [*writing*]. To whom?

BAGLIONE. To various and sundry persons. I have them here,
and I . . .

MAGISTRATE [*never looking up*]. Read them.

BAGLIONE. What's that? . . . Well, if Your Excellency can stand
them . . . I suppose I can. [*He puts on his spectacles and
shuffles his papers.*] Here's one. [*He reads.*] "Gian Bagaglia
. . ." [*He pauses.*] Are you . . . Are you sure you want me to
. . .

 [*The* MAGISTRATE *nods.* BAGLIONE *shrugs his shoul-
ders.*]
"Gian Bagaglia, broken-hearted
Tried to paint and only farted
Told the priests he was profound
You can't tell paint from piss, you hound."

CARAVAGGIO [*to the* MAGISTRATE]. It's the truth; he can't.

BAGLIONE.
 "Have mercy Gian, cut out that stuff,
 The Blessed Virgin's suffered enough
 Take your works to the market, please,
 They need wrapping for their cheese.
 As for painting, take a rest,
 Pimping's the thing that you do best."

CARAVAGGIO. It may not be good poetry, but it's true. As a
painter this man is so unbelievably bad . . .

MAGISTRATE [*to* BAGLIONE, *rapping his gavel*]. What do you
want?

BAGLIONE. I want him put into prison, that's what I want. Into the Tor di Nona, with the rest of the scum. I want him kept there, until he learns to respect his betters!

CARAVAGGIO. My betters! You scoundrel! The only time you even pretend to be a painter is when you copy me! The reason, the reason you want me put away is so that you can grab some of my commissions! You think . .

MAGISTRATE [*rapping with his gavel*]. That's enough!

CARAVAGGIO. . . . that if I'm locked up long enough, . . .

MAGISTRATE. One month.

CARAVAGGIO. A month! I . . .

MAGISTRATE. Last year, it was the woman with the broken windows.

CARAVAGGIO. She locked me out!

MAGISTRATE. Then it was the waiter, Pietro.

CARAVAGGIO. He insulted me!

MAGISTRATE. Now these verses. One month! [*He raps his gavel.*] Case dismissed.

CARAVAGGIO [*as the lights dim*]. Lena! . . . Take care of my canvases! . . . Don't let anyone touch them! . . . Anyone! . . .

[*The lights rise again.* CARAVAGGIO *looking shabbier, is back in the prisoners' dock.* LENA *and* LONGO *still stand in one corner of the Court;* TRISEGNI *is gone. A* CORPORAL *of the Guard in full regalia is on the witness stand. He reads from the notebook.*]

CORPORAL. It was one twenty a.m. in the Piazza Navona. I was making my rounds with my men, at which time defendant proceeded into the square attired in a sword and dagger.

CARAVAGGIO. That's my right!

CORPORAL. Judging his condition to be such as to constitute a
 disturbance to the peace, I ordered my men to detain him.
 They did so. I then instructed defendant to produce his
 license to bear dangerous weapons. Defendant then pro-
 duced said license. I then dismissed him. I said: "You are
 now free to proceed. You are free to proceed," I said. To
 which defendant replied: "F . . ." [*He checks himself.*]
 "Shove it up. You may shove it up," he said.

CARAVAGGIO. He grabbed hold of me as if I was a common . . .

CORPORAL. Judging it to be my duty, I placed defendant under
 arrest. Which arrest, he resisted. I therefore ordered my
 men to escort defendant to the Tor di Nina. They did so,
 and, as they marched him off, defendant cried out in a loud
 voice so that all around could hear: "You, and as many as
 are with you, you can all . . . shove it up!"

CARAVAGGIO. By what right, by what right did you have me
 thrown into the . . .

CORPORAL. By the right of the authority vested in me by His
 Excellency.

CARAVAGGIO. You police, you're all the same!

CORPORAL. We do our job; protecting decent people.

CARAVAGGIO. Just because you're in uniform, you think you
 can push the rest of us around.

CORPORAL. And you—you think that because you dab a bit of
 paint on a canvas, you're above the law!

 [*The following lines are spoken simultaneously.*]
CARAVAGGIO. It's always ten against one with you and your
 gang! . . .
CORPORAL. Troublemakers, all of you! Giving our city a bad
 name!

MAGISTRATE [*rapping his gavel*]. That's enough!

 [*The following lines are spoken simultaneously.*]

CARAVAGGIO. Come on a real brawl, a good brawl, and you look the other way . . .

CORPORAL. No respect for authority. Never a civil word for us poor police who . . .

MAGISTRATE. That's . . .

[The following lines are spoken simultaneously.]

CARAVAGGIO. But, you see one man, just one man, walking down the street at night, and up you come, strutting and swaggering . . .

CORPORAL. . . . try to keep the peace. Whining about your rights; running off to your patrons to protect you, whenever you get caught doing something wrong.

MAGISTRATE. . . . ENOUGH!

CORPORAL. . . . Dirty, unshaven, foul-mouthed! Wear the same shirt until it peels off your back! And smell! You smell like . . .

CARAVAGGIO. And that's a crime I suppose!

MAGISTRATE *[still rapping his gavel]*. Order!

[The following lines are spoken simultaneously.]

CARAVAGGIO. You show me the law that tells me how to smell! You show me! I dress as I please, and I smell as I please! And no bully, no overgrown bully . . .

CORPORAL. Like pigs! Like filthy pigs, the lot of you! A good flogging is what you need! Then a good bath! And after that a sentence at hard labor . . . a bit of honest labor for . . .

MAGISTRATE. Two months . . .

[The following lines are spoken simultaneously.]

CARAVAGGIO. . . . dressed up like a clown! . . . Clowns, all of you! Buffoons! . . . Toads! . . . Lackeys! . . .

CORPORAL. . . . for all of you slackers! Slugabeds, all of you! Layabouts! Protestants! Guttersnipes! . . .

MAGISTRATE. Two months! In the Tor di Nona!

CARAVAGGIO. But . . . it's dark down there! My eyes suffer! they're inflamed when I come back into the light! It's damp down there! By the time I come back up my knuckles are all swollen! Look at them! They're still so swollen from the last time that I can barely hold my brushes! And the food! They feed you garbage down there! It makes me retch!

MAGISTRATE. You should have thought of that before.

CARAVAGGIO. I can't go back down there! My paint will be dry by the time I get out, my model . . .

MAGISTRATE [*rapping his gavel*]. Case dismissed.

CARAVAGGIO [*as he is led away*]. Lena! . . . My canvases! . . . [*She is gone.*]

[*The lights dim. When they rise again,* LONGO *alone stands in the corner of the courtroom.* CARAVAGGIO, *still shabbier, is back in the prisoners dock.* PASQUALONE *is on the stand. He is dressed in a manner which, in his opinion, accords with his rank. He wears a bandage as big as a turban wrapped around his head. His friend who accompanies him, Master* ROCCASECCA, *is older, and being hard of hearing, may carry an ear trumpet.*]

PASQUALONE. Pasqualone, Pa-squa-lo-ne. Mariano. Ma-ri . . .

MAGISTRATE. Profession.

PASQUALONE. Profession. By all means. Notary. In the service of . . .

MAGISTRATE. Complaint.

PASQUALONE. Complaint. Yes indeed. I was assaulted, brutally assaulted by the prisoner, Merisi. It was only by the Grace of God . . .

MAGISTRATE. Time and place.

PASQUALONE. Time and place. It was last Friday in the Piazza

Navona. I was taking the air with Master Roccasecca.

ROCCASECCA. Eh? . . .

PASQUALONE. Ro . . . ca . . . sec . . .

ROCCASECCA. From Accumoli.

PASQUALONE. With Master Roccasecca, writer of apostolic let-
ters. We take the air together every Friday. From six to
seven p.m.

ROCCASECCA. You the Magistrate? . . .

PASQUALONE. It was last Friday then. And as we were strolling
. . .

ROCCASECCA. Ought to be ashamed of yourself!

PASQUALONE. . . . as we were strolling . . . at approximately six
forty-seven, I felt a terrific blow on the back of my head. I
realized at once that someone had struck me. You can see
for yourself that I was in fact struck. Here on my head.

ROCCASECCA. No, no! Not on that side! It was on the other side!

PASQUALONE. This side!

ROCCASECCA. The other side! Here! Here is where you were
struck!
 [MAGISTRATE *raps with his cane.*]

PASQUALONE. It was here. On my head. My friend, Master . . .

MAGISTRATE. Go on!

PASQUALONE. Well! . . . I fell to the ground. At once! If I had not
done so, I would have been killed, yes, killed by this ag-
gressor who was so cowardly as to assault me from behind.

CARAVAGGIO. Cowardly! You were the coward! First you in-
sulted me. Then, when I challenged you, you refused to
wear a sword1

PASQUALONE. I would have been killed! But Master Roccasecca
. . .

ROCCASECCA. Eh?

PASQUALONE. I WOULD HAVE BEEN KILLED, I SAID, BUT
. . .

ROCCASECCA. Not so fast! . . . Not so fast! . . .

PASQUALONE. . . . BUT YOU SAVED ME! YOU CRIED OUT
. . .

ROCCASECCA. Ah! . . . You're talking about what happened out
there! In the Piazza!

CARAVAGGIO. Last Friday.

ROCCASECCA. Scandalous! . . . Shocking! . . .

MAGISTRATE. GO ON!

ROCCASECCA. Well then! . . . We were taking the air, I and Mis-
ter Pasqualone . . . He's also from Accumoli . . . We were
taking the air in the Piazza Navona, and he was talking
about . . . Well . . . I forget now what he was talking about
. . . And then . . . he stopped talking! . . . I turned to him to
say "go on, go on!" And, he wasn't there! . . . Well now,
what's happened to the fellow, I said to myself. And then I
saw him. Lying on the ground! And holding his head! This
side of his head. Well, I said to myself . . . something's
happened to him, that's for sure! So I . . . What did I do? . . .

PASQUALONE. YOU CRIED OUT . . .

ROCCASECCA."Help, help!"

PASQUALONE. Whereupon, the aggressor fled!

CARAVAGGIO. I, fled? . . . I'd have throttled you with my bare
hands if the police hadn't . . .

PASQUALONE. So you say! But, Master Roccasecca will confirm
. . .

MAGISTRATE. That's enough! [*To* CARAVAGGIO.] You say he in-
sulted you. It was a matter of honor then?

CARAVAGGIO. My honor . . . There was a woman . . . I'd used her for my paintings of the Blessed Virgin. I would have used her many times more. But this swine drove her from me.

MAGISTRATE [*to* PASQUALONE]. Well?

PASQUALONE. There was . . . a certain . . . altercation. I had made the acquaintance of a certain young female. Lena was her name. I had, after much deliberation, gone so far as to announce my intentions to her mother. Of course I had every reason to suppose that her mother, a poor woman, would support my suit. Whereupon this painter, Merisi, burst into her lodgings. In a frenzy! Like a wild beast he was! Tried to drag her off with him, back to his studio, I suppose. She resisted . . . even so . . . A man in my position could not possibly undergo the scandal that would have followed . . . I washed my hands of the entire affair.

CARAVAGGIO. You went up and down the Piazza calling her a whore and me a whoremonger!

MAGISTRATE. Well?

PASQUALONE. I may have dropped a remark here and there about Merisi. I could hardly have lowered his reputation.

MAGISTRATE. And what happened to the girl?

PASQUALONE. I wouldn't know.

CARAVAGGIO. You swine! I should have parted your skull for you, out there . . .

PASQUALONE. You see? You see?

MAGISTRATE. He's right. If I let you go, you'll only attack someone else. So it's back to the Tor di Nona . . .

CARAVAGGIO. But . . . I can't go back there! I have three paintings to finish. One for the Duke of Modena . . .

MAGISTRATE. So his agents have told me.

CARAVAGGIO. One for the Cardinal Borghese. And one for the Holy Father . . .

MAGISTRATE. So I've been told.

[*To* PASQUALONE.] Will you accept his apology like a Christian gentleman?

PASQUALONE. Well . . . I . . . [*He and* ROCCASECCA *withdraw to a corner to confer.* PASQUALONE'S *stage whispers may be heard.*] . . . abject apology . . . yes . . . My sword? . . . but supposing he should challenge me? . . . Ah! . . . yes, yes, my reputation! . . .

[*He returns to address the* MAGISTRATE.] If, as you say, it would be the part of Christian gentleman . . . then . . . I would consider accepting his abject apology . . . But . . . [*Roccasecca prompts him.*] . . . He must beg my forgiveness! . . . Yes! . . . And he must affirm in writing, that, when, I grip my sword in my hand . . . I am fit to stand my ground against him or any other man! He must affirm that! My reputation is at stake!

MAGISTRATE. Take this down.

[*Dictating to* CLERK.] "I Michaelangelo Merisi . . . having been insulted by Mister Mariano . . ."

PASQUALONE. Pasqualone . . . Pa . . . squa . . .

MAGISTRATE. Clerk . . .

PASQUALONE. Notary!

MAGISTRATE. ". . . and because he would not wear a sword . . . resolved to strike him . . . whenever I should meet him . . . I am truly sorry for what I did . . ."

PASQUALONE. He should be!

MAGISTRATE. ". . . and I beg . . ."

PASQUALONE. "Humbly beg" would be better . . .

MAGISTRATE. ". . . his forgiveness . . ."

CARAVAGGIO. Ah!

MAGISTRATE. "I further declare . . . that I regard Mister Mariano . . . [*A low groan from* PASQUALONE.] . . . when he grips

his sword in his hand . . . like a man . . ."

PASQUALONE. Yes!

MAGISTRATE. ". . . as one fit to stand his ground . . . against me or any other man . . . Signed" . . . Now . . . sign it . . .SIGN IT! . . . and give it to him . . . GIVE IT TO HIM! . . .
 [*To* CARAVAGGIO, *as he takes the statement.*] Next time, you won't get off so lightly!

CARAVAGGIO [*to* PASQUALONE, *as he throws the statement at him*]. Nor will you! Next time, I'll chop off your head!

Act I

Scene VI

[*A shack on the banks of the Tiber at the end of the day,*
1605.
 A ramshackle room—the door, half open, swings on a bro-
ken hinge. A sack is stretched across a paneless window. The
walls are made up of old doors; coils of fish line and nets cover
the floor. Three stools and one dirty cot make up the furniture.
 Sounds of heavy breathing outside; the FIRST FISHERMAN,
an old man, moves into the doorway, carrying the limp body
of LENA, *clad in her red, now muddy, robe.*
 He stands looking around the room. He sees that there is
no place to dump her on the floor. He looks at his cot, sighs,
and unloads her onto the cot. He straightens up, pressing one
hand against his back.
 He looks down at her, and sits beside her shaking his
head. He squeezes her mouth.]

FIRST FISHERMAN. Don't look so sad then . . . it's over. [*He folds*
 her hand across her chest. He moves to a stool and starts
 to work on his lines.]

[*The* SECOND FISHERMAN, *also old, tramps up to the door-way. He dumps his lines outside and comes in carrying his small catch of fish. He sees the body; he shrugs and moves to a stool. He sits and begins to clean his fish. Pause.*]

SECOND FISHERMAN. Who is she?

FIRST FISHERMAN. Don't know.

SECOND FISHERMAN. What's she doing here then?

FIRST FISHERMAN. Came in on my lines.

SECOND FISHERMAN. Every day the same.

FIRST FISHERMAN. Dead dog.

SECOND FISHERMAN. Old mattress.

FIRST FISHERMAN. Never can tell what you'll bring in these days.

SECOND FISHERMAN. Not any more. [*They work in silence.* CARAVAGGIO, *carrying a satchel comes to the doorway.*]

CARAVAGGIO. I was working, and my boy ran in . . . [*The* FISHERMEN *pay no attention.* CARAVAGGIO *sees the body and goes to it.*] I've been hunting all over Rome for you! [*He crouches beside* LENA.] I needed you! [*He draws her eyelids down.*] You could have held on like the rest of us. [*He studies her face.*] As you are then . . . as you are.

FIRST FISHERMAN. Who's he?

SECOND FISHERMAN. Not from around here.

FIRST FISHERMAN. Husband? [CARAVAGGIO *tilts* LENA'S *head and places her arms as he wants them.*]
	Brother? [CARAVAGGIO'S *hands move swiftly over her body: rearranging her legs, her hands, her robe. The* FIRST FISHERMAN *watches.*]
	A thief!

SECOND FISHERMAN. Thinks he'll find a ring on her finger.

FIRST FISHERMAN. A purse in her pocket.

SECOND FISHERMAN. Claim they belong to him.

FIRST FISHERMAN. What you up to Mister? . . . eh?

CARAVAGGIO [*working*]. I'm a painter.

SECOND FISHERMAN. Never mind that! Answer the question!

CARAVAGGIO. It's for a painting. [*pause.*]

FIRST FISHERMAN. A painting!

SECOND FISHERMAN. Of her? Who'd want a painting of her?

CARAVAGGIO [*working*]. The Carmelites.

FIRST FISHERMAN. What would they want with her?

SECOND FISHERMAN. Don't even want us in their church, not those high and mighty ones.

FIRST FISHERMAN. The fish we catch, yes; but not the fishermen.

SECOND FISHERMAN. Not her; they won't even pray for her.

FIRST FISHERMAN. Not the way she died.

SECOND FISHERMAN. Trash is all she is.

CARAVAGGIO. She'll do. [*pause.*]

SECOND FISHERMAN. For what, Mister? . . . She'll do for what?

CARAVAGGIO. For the Virgin.

FISHERMEN. The Virgin! [*As they talk, they set down their work and move until they stand over him.*]

SECOND FISHERMAN. What's he talking about!

FIRST FISHERMAN. Up there, Our Lady is!

SECOND FISHERMAN. Where she belongs!

FIRST FISHERMAN. Don't know what you're up to Mister . . .

SECOND FISHERMAN. But we don't like it!

FIRST FISHERMAN. May not take to priests around here. . .

SECOND FISHERMAN. But we respect Our Lady!

FIRST FISHERMAN. Pray to her, we do.

SECOND FISHERMAN. And we'll not have you pissing on her!

[CARAVAGGIO *ignores them and goes on working. The* THIRD FISHERMAN *moves into the doorway. He dumps his lines and enters. He sees* LENA.]

THIRD FISHERMAN. Came in here, did she. [*No response.*] They were dragging for her up river. [*He sees* CARAVAGGIO.] What's he doing here?

FIRST FISHERMAN. Calls himself a painter.

THIRD FISHERMAN. Painter! . . . Here, give me a hand . . .

CARAVAGGIO [*Picking up a knife in place of his pencil*]. Leave her . . . as she is.

THIRD FISHERMAN. Dead, that's how she is! Cold, covered with mud from the river where she ended up. When you'd finished with her.

CARAVAGGIO. I haven't finished with her.

THIRD FISHERMAN. A decent burial, that's all she needs now.

CARAVAGGIO. Mine, she's mine. [*A long pause.*]

THIRD FISHERMAN. You, you were hard on her.

CARAVAGGIO. As I am on myself.

THIRD FISHERMAN. It's not the same. [*Standing over* LENA.] She was young. She had a long life in front of her.

CARAVAGGIO [*working again*]. Thirty years, forty years.

THIRD FISHERMAN. It's enough. It's as much as any of us get. But now, thanks to you . . .

CARAVAGGIO. Thanks to me, she'll live forever.

THIRD FISHERMAN. Ah!

CARAVAGGIO. In Santa Maria. Thousands will see her there. And worship her.

THIRD FISHERMAN. Worship! You think that's what she wanted!

CARAVAGGIO. I don't care what she wanted.

THIRD FISHERMAN. A roof over her head. A fire through the winter. Soup in her bowl. A bed. That's what she wanted.

CARAVAGGIO [*working*]. It's not enough.

THIRD FISHERMAN. It's all there is for us.

CARAVAGGIO. It's for you that I paint, so that you will . . .

THIRD FISHERMAN. Well, we don't want your paintings! Or you with your crazy notions about Our Lady. You say she'll live forever, thanks to you. I say, better another day; better one more day alive and content with her lot than a thousand years above some altar where you . . .
 [CARAVAGGIO *rises, furious.*]

CARAVAGGIO. What are we, animals, that we live so meanly? Why are we alive at all? To grub in the earth until the earth is shovelled over us? You, blind as you are; me, ugly as I am; we're more than beasts, I tell you, much, much more!! There's majesty in all of us, majesty! In this man's skull, in that one's weatherbeaten skin. In your dim eyes. In this dead woman. In her hands, in her neck, in her tired face at rest. Yes, she's Our Lady, for me! They came from the same source. They shared the same gift of bearing new life in their bodies. They're fragments, both of them, of the same design. As all women are. All women! Not just one! And all men! Can't you see that?
 [*No response from the* FISHERMAN.] No? . . . Well. I see it.
 [*He returns to his work.*] And I'll make others see it. Through her. Yes, and through you as well, all of you. So . . . do what you want. But, I'm staying here. And she's

staying with me. Until I've finished with her.

THIRD FISHERMAN. It's been two days or more she was in the river.

SECOND FISHERMAN. Smells. She smells already.

CARAVAGGIO. Leave us alone then. Until I'm through. [*A pause.*]

[*As* CARAVAGGIO *continues to work, the light dims down to a shaft which illuminates the men and* LENA *as they are seen in* CARAVAGGIO's *painting,* The Death of the Virgin.]

Act I

[*In Santa Maria della Scala, Rome: May, 1606.*
Caravaggio's painting, The Death of the Virgin, *hangs, un-*
framed over the altar in a side chapel of the church. He stands
in front of the altar, confronting a number of angry and excited
FRIARS, *all members of the Order to which the church is at-*
tached. They wear the robes of the Discalced Carmelites.
They are Spaniards, and in contrast to DEL MONTE *and* FATHER
FIRMO, *they are rigid and fanatical.*

FRIARS. [*shouting all at once*]. An affront! . . . An affront to our
Blessed Lady! . . . *Quasi cedrus exaltata sum* . . . Here, in
the Church of Santa Maria, . . . Here where the holy relics
of the Blessed Saint Theresa . . .

FATHER PETER. Reverend Fathers! Dear Brothers! I beg you! Let
us proceed with our discussion in an orderly way!

 [*The following lines are spoken simultaneously.*]
FRIARS. No discussion! . . . We need none! . . . We know what
we want! If the Blessed Saint Theresa takes offense . . .
Quasi oliva speciosa . . .

FATHER PETER. . . . We will discuss it . . . We . . .

FATHER PETER. We will discuss it! I remind you, fathers and brothers, as your Superior, I remind you that we voted one year ago to commission this painting . . .

FRIARS. Yes, we voted . . . but not for this! . . . *speciosa in campis* . . . we voted for a painting to glorify our Blessed Lady . . . Now . . . Now we are forced to take this . . .

FATHER PETER. Nothing, nothing is forced upon us! So, be silent!
[*He motions.*] The Venerable Ferdinand.

FERDINAND [*who is old and querulous*]. He paints in error! The writings, the apostolic writings tell us that at the appointed hour when the apostles had gathered around Our Lady, she made them sit down. She made them *sit*, but he has painted them standing!

CARAVAGGIO. Some are standing; some are sitting.

FERDINAND. Yes. But she made them all sit. While she showed them the branch of palm that she was given by the angel. Where then is the palm? Where is the branch of palm in this painting?

CARAVAGGIO. I show a later hour.

FERDINAND. He shows a later hour! Well, we know what happened then too! Saint Peter, dressed as a priest, reads the ritual. A second apostle holds the aspersorium; a third the stoup of holy water, a fourth the thurible. It is all recorded. Where then are these? Where are all these?

CARAVAGGIO. That hour is still later. My hour is earlier than that.

FERDINAND. First it is later. Then it is earlier. This one, who presumes to portray the Blessed Lady, he does not know when . . .

CARAVAGGIO. I have read the scriptures! I know the story. I know that the Virgin lay in her chamber awaiting death.

And that in the third hour of the night thunder struck the house. And Jesus said to his mother, "Come, thou chosen among women!" And she answered, "Lord, my heart is ready." I know that! And I know that when her spirit had risen and her body remained in the chamber, the apostles awoke and wept. That, that is the hour I have portrayed.

FERDINAND. So. That is the hour! Well, it is told that at that very hour, three damsels put forth their hands to lift up the body which thereupon gave forth a light so bright that they could not look upon it. Where then are these damsels?

CARAVAGGIO. One sits on the chair.

FERDINAND. And the other two?

CARAVAGGIO. I . . .

FATHER PETER. Say what you wish to say.

CARAVAGGIO. I know what is recorded. Every last word. But, I am not governed by words. The hour with its sadness governs me. It fills my heart with awe. My whole heart. And that is what I portray.

FERDINAND. That may be. But it is not what was ordered.

FRIARS. And painters . . . painters should do what they are ordered to do! Painters . . .

FATHER PETER. Silence! [*He motions.*] Father Dominic.

DOMINIC. This woman, who sits in the foreground. Her dress is torn, is it not?

CARAVAGGIO. It has a small tear.

DOMINIC. I thought so. And the one you portray as Our Lady. She wears no robe of velvet; no shawl of silk and gold. She is clad, is she not, in a coarse, red garment.

CARAVAGGIO. As many are clad.

DOMINIC. The bed on which she lies. It is, is it not, a bare, frame bed.

CARAVAGGIO. It is a bed like any other.

DOMINIC. The bolster on this bed. Is it soiled? Or do my eyes deceive me? [*Pause.*]

CARAVAGGIO. It is soiled.

DOMINIC. He admits it! And why is it soiled? Why, dear fathers and brothers? Remember, I beseech you, that the body which lies on this bed was whiter than the whitest of lilies; purer than driven snow! Are we to suppose that her body soiled the bed?

FRIARS. Blasphemy! . . . Blasphemy!

DOMINIC. Well? . . . We are waiting.

CARAVAGGIO. She was poor . . .

A FRIAR. She was not poor!

CARAVAGGIO. And the poor lie on beds that are soiled. The people of this district will understand that.

DOMINIC. So! It is for their edification that the bed is soiled! And the robes of these men, who are said to be the apostles, they are also soiled. Look at them, fathers and brother; look at them closely! Are they the saints we honor and revere, or are they common cobblers, rag pickers, knife grinders?

CARAVAGGIO. Rag pickers and knife grinders live all around you, here, in the Trastevere. It is from such men that the saints come.

DOMINIC. We need no instruction from you. That curtain that hangs above the bed. What does it represent?

CARAVAGGIO. It's a part of the painting; a vital part!
　　[*He springs up on the altar and faces the painting.*] I start with the red robe of Our Lady, on her bed. I anchor it to the earth with the earth color of the woman beside her. I balance the warm reds with the cold robes of the mourners. And then, in the curtain. I take the blood red of her

body again and I lift it up, I bear it upward in a great sweep!
It frames the whole setting; it gives it . . .

DOMINIC. Answer my question! What does it represent?

CARAVAGGIO. My feeling! My burning conviction of what is
demanded to give order and glory to a work of art!

DOMINIC. What is demanded is obedience to our instructions!

FRIARS. Others obey our instructions! Others carry out our or-
ders!

CARAVAGGIO. Then go to the others! But don't expect the poor
to come to you!

DOMINIC. The poor! Do the poor know better than we . . .

CARAVAGGIO. They know the gospels as they know their own
empty pockets! I beg you, let the painting hang here!
They will embrace it as their own!

DOMINIC. Vulgar cant! It is not understanding that binds the
faithful to their Church! It is veneration! Worship for the
one woman who was set apart from all others, who was
crowned by Our Lord and who sits now at His side on her
throne of solid gold! Mary, Queen of Heaven! Blazing with
rubies and diamonds! She, and not that squalid creature is
the one whose blessed countenance belongs above our al-
tar! I say: throw this one out! Destroy it!

FRIARS. Out with it! . . . Enough! . . . Before it defiles us! . . .
Now!

FATHER PETER. SILENCE! . . . Are there others . . . who wish to
speak?

FRIARS. No more! . . . No more!

FATHER PETER. If there are no more . . .

FATHER THOMAS. I . . . if I may . . .

FRIARS. No! . . . He's just a boy! . . . A beardless boy!

FATHER PETER. SILENCE! . . . If he wishes to speak, he will be heard.

FATHER THOMAS. I respect my elders . . . I . . . I accept all that they said . . . but . . . fathers fathers and brothers . . . as the painter spoke . . . as he spoke of the awe that filled his heart . . . I felt my own heart fill with the same, the same awe! . . .

FRIARS. Nonsense! . . . That's enough! Dominic . . .

FATHER PETER. SILENCE!
 [*To* FATHER THOMAS.] Continue.

FATHER THOMAS. I . . . I think it is true . . . that the poor live all around us. And when he said, let it hang so that the poor can see it . . . I . . . I can't see that it would do any harm.

FATHER PETER. Thank you . . . Now . . . are there others? . . . are there none? . . . Then I wish to speak. For it was I who brought before this Chapter, the name of Caravaggio. A famous name, fathers and brothers; he is foremost among the painters of our day. And this painting may add to his reputation. It may, as he says, bring the people of this district and many more to our Chapel, here, where we live so far from our homeland, through the kindness of His Holiness. I for one concede that. Nevertheless this painting arouses doubts in me. It arouses grave doubts which I wish now to be dispersed, or else confirmed.
 [*To* CARAVAGGIO.] This woman, who lies upon her bed of death; it is said that she is taken from a real woman. Is that true?

CARAVAGGIO. Everything that I portray is from life. For me all else is child's play.

FATHER PETER. It is said that this woman was known to you.

CARAVAGGIO. I paint what I know.

A FRIAR. Everyone knows who she was! She was a whore!

ANOTHER FRIAR. A dead whore! She drowned herself!

CARAVAGGIO. She was my model. She died.

FATHER PETER. She was dead. She had been dead for two days or
more when you painted her. [CARAVAGGIO *nods.*] For how
long did you imitate her?

CARAVAGGIO. Two days and two nights.

FATHER PETER. She changed in that time, did she not? As we all
change, we who are subject to the laws of death. [*He
waits.*] Come; you are too fine a painter not to record the
changes. These legs of hers, they are swollen, are they not?
Her wrist, her fingers, her eyelids, they are all swollen;
they are beginning to bloat. And her pallor. The skin of
this girl in the foreground is a healthy color; she is living.
But, the pallor of the woman on the bed is grey. It has a
green hue. She is a woman three days dead. And, in death,
she is decomposing. That is true, is it not?
 [*He waits.* CARAVAGGIO *is silent.*] It is true. My suspi-
cions are confirmed. [*To* CARAVAGGIO.] I will say this
much to you. I do not know whether your painting reflects
your misguided zeal as an artist or whether it points to
some deep and dreadful heresy. If I were a counselor of the
Holy Office of the Inquisition, I would pursue that ques-
tion to its end, and I would act accordingly. But, I am
merely the Superior of this Chapter. So, to you fathers and
brothers, I say, I who was responsible for commissioning
this painter say, nothing, nothing that has been mentioned
so far in condemnation of the painting before us compares
in gravity to that which is now revealed! And, now that it
is revealed, we have no choice; we must find that the
painting is abhorrent; damnable!
 For death and corruption were designated by Almighty
God as the penalties of sin. It is because we were born in
sin that we suffer death and corruption. But Mary, Mary
alone of all humans was free of sin. So she was exempt
from the bonds of death. *Transitus Mariae, transitus
Mariae!* She did not die; she passed through death! That,
that is dogma. And all else is blasphemy! To say that she

died and suffered corruption is to say that Jesus Christ, our Saviour was born in sin. And that is blasphemy, blasphemy! Heretics may believe that while they live. Luther and his accursed followers may believe it. But no Catholic has ever believed it and none ever will! Not for as long as the Holy Office of the Inquisition endures. [*He pauses.*]

For the sake of procedure, I call for the vote. [*He is given two chalices shaped like cups. He raises the one which he holds in his left hand.*] This chalice is for acceptance of the painting. [*He raises the chalice which he holds in his right hand.*] This one is for its rejection.

[*The* FRIARS *form lines. As they pass* FATHER PETER, *they place a ball in one chalice. When they have voted,* FATHER PETER *holds both chalices out. He turns the chalice in his left hand upside down.*] The Chapter has chosen; there is not one dissenting vote.

[*To* CARAVAGGIO.] We find your painting to be unacceptable. It has no place in this chapel. It must, and it will be removed before we reassemble for Vespers. [*He leaves the chapel. The* FRIARS *follow him.*]

[CARAVAGGIO *watches them go. He begins to loosen the fastenings which hold the painting to the wall. He pauses. He brushes some dust from the Virgin's body.*]

CARAVAGGIO. Lena . . . Lena . . . Your legs *were* swollen. And your wrists. Your fingers *were* swollen; I felt them, so I know. Your eyelids *were* swollen; I *know* that. I was the one who drew them down over your eyes. Your skin *was* grey, turning green. I showed it all, as the friar said; I had to. It was the truth; it was the whole truth for me. I don't know what happened to Our Lady sixteen hundred years ago. But I know what happened to you. You drowned in the Tiber. You drifted around in the mud and the weeds until the old man fished you out. Your robe was still dripping onto the ground when I started to sketch you. I slept on the ground, beside you when I couldn't keep my eyes open. When I awoke, I started to work again. I knew that I'd

never get another chance like that. I made the most of it. I made a masterpiece; a masterpiece of you.

As for these pedants, the thought of what they wanted never entered my head. Nothing existed for me except the two of us. After a time, the others left, holding their noses. I worked until I finished; then I called the others back. We wrapped you up and buried you by the river. We tried to get a priest to come and say a prayer for you. There wasn't one who would come to say a prayer. [*He whirls around.*] You say that she was a whore and that she drowned herself. I don't give a damn! She was a woman. She died. I painted her, just as she was. That's all. That's all! I don't tell you what to preach; don't you tell me what to paint! I am not your servant; I am my own master in the world of my own creation! It is my world, and if you enter it, you enter it on my terms! You can't buy me with money to carry out your orders! And you won't stop me with your threats of burning! I won't be burned as a heretic for you! And I will paint; *as I please!*

[*He turns back to the painting.*] You were dead. [*He shouts over his shoulder.*] And stinking; dead bodies stink!

Act II

PROLOGUE AND SCENE I

[BAGLIONE *saunters onto the stage, dressed for a game of court tennis. He wields a court tennis racquet and uses it to bounce a tennis ball.*]

BAGLIONE [*to a member of the audience*]. What did you say?
 . . . You want a demonstration? . . . Why not? [*He demonstrates.*] The forehand . . . The backhand . . . The serve
 . . . It's a pleasant pastime . . . much in vogue . . . for two
players or four . . . Gentlemen only, of course . . . There is
another version . . . played by rowdies in the streets . . .
against a wall, if they can find a wall . . . They play for
money.
 That's what Merisi was doing back in May . . . It
wasn't long after his row with the Carmelites . . . you re-
member . . .
 He was playing with that fellow Longo . . . and a well
bred young chap named Ranuccio Tomassoni . . . Needless
to say, the game ended in a brawl . . . Ranuccio gave Mi-

chaelangelo a thrust or two with his dagger . . . Then he
caught one . . . here . . . he died, unconfessed.

Well . . . none of his friends could save Michaelangelo
after that. . . . He hid out in the mountains with Marzio
Colonna . . . a pirate if there ever was one! . . . Then he
made his way to Naples . . . He relieved a few people of
their money, in exchange for a painting or two . . . And,
where did he go next? . . . To Malta.

Malta! The fortress of the Knights. Where no trans-
gressor lives to tell his tale . . . Obedience . . . conformity
. . . that's what the Knights demand . . . Disobey their
Grand Master, once he gets hold of you . . . well . . . if he
has a tender spot in his heart for you . . . he stuffs you in a
sack . . . along with a few boulders . . . and drops you off . . .
at sea . . .

[*A deep bell sounds.*] Michaelangelo . . . with the
Knights? . . . [*He shakes his head in incredulity.*] Why did
he risk it? . . . Why did Icarus fly?

[*The bell continues to sound. The lights rise on a room in
the Palace of the Grand Master in Valetta. The* GRAND MASTER
and his PAGE *stand, motionless, as they are seen in* CARAVAG-
GIO's *painting.* CARAVAGGIO *works on the painting. The* LORD
PRESIDENT, *seeking instructions, holds a number of scrolls. He
also stands motionless for as long as the bell sounds. Then, he
unties a scroll.*]

LORD PRESIDENT. We have an hour. May I continue?

GRAND MASTER. Continue.

LORD PRESIDENT [*unrolling and reading the scroll*]. "From the
 Grand Prior of Venice: to His Most Eminent Highness"
 etcetera.

GRAND MASTER [*a rebuke*]. "Etcetera?"

LORD PRESIDENT. I beg your pardon . . . "To His Most Eminent
 Highness, the Grand Master of the Sovereign Military
 Order of the Knights of Saint John of Jerusalem . . . Admi-

ral of the Fleet, Count Sforza, has the honor to report . . .
The galleys captured in the engagement of Lampedusa,
have been hauled into port . . . Included in the booty are:
six hundred barrels of oil . . . one hundred sacks of fine
cloth . . . seventy-seven crewmen . . . to be sold as slaves
. . ."

GRAND MASTER. No gold.

LORD PRESIDENT. He makes no mention of gold.
 [*He unrolls and reads an elaborate scroll.*] "From His
Most Noble and Serene Majesty, Philip the Third . . ."

LORD PRESIDENT and GRAND MASTER. . . . "King of Portugal by
the Grace of God; King of Spain; King of Sicily; King of
Naples . . ."

LORD PRESIDENT. ". . . To His Most Eminent Highness, the
Grand Master of the Sovereign Military Order of the
Knights of Saint John of Jerusalem. Mindful as we are of
our affection for all who employ their arms against the
enemies of Our Holy Faith, and . . ."

LORD PRESIDENT and GRAND MASTER. ". . . remembering our
special affection for the Sovereign Military Order . . .

GRAND MASTER. Yes, yes. What does he want this time?

LORD PRESIDENT. He wants the Priory of Oerato, for his neph-
ew, the Duke of Savoy.

GRAND MASTER. So that he can increase his revenues from the
Piedmont. The answer is *no*. [*The* LORD PRESIDENT *bows.*]

[*The* GRAND MASTER *glances at* CARAVAGGIO, *who motions
to him to raise his chin. He does so. In the silence a faint
scream can be heard from beneath the stage.* CARAVAGGIO
looks at the three in turn. None appears to have heard it.
 The LORD PRESIDENT *unrolls and studies a small scroll. He
glances at* CARAVAGGIO.]

LORD PRESIDENT [*to the* GRAND MASTER *in an undertone*]. The
following . . . is for your ears only.

GRAND MASTER [*also in an undertone*]. He is to be trusted.

LORD PRESIDENT. Not by me!

GRAND MASTER. He is soon to be made one of us.

LORD PRESIDENT. Not by my vote! He's a common criminal!

GRAND MASTER. That's a damnable falsehood!

LORD PRESIDENT. A fugitive from justice then; he killed a man.

GRAND MASTER. We have all drawn blood.

LORD PRESIDENT. The blood of infidels; he killed a Christian gentleman!

GRAND MASTER. He is quick to draw his sword.

LORD PRESIDENT. The Holy Father banished him from Rome.

GRAND MASTER. Rome's loss is Malta's gain.

LORD PRESIDENT. If you persist . . .

GRAND MASTER. I do!

LORD PRESIDENT. You'll live to regret it! The man reeks of treachery!

GRAND MASTER. That's enough! . . . You may proceed with your report.

LORD PRESIDENT. Very well. [*In a low voice, nonetheless.*] A Papal messenger left this morning for Rome. Incognito. He carried a concealed message from the Archbishop to His Holiness. [*He glances at* CARAVAGGIO.] Needless to say, we took the precaution to . . . that is to say we . . .

GRAND MASTER. Read it.

LORD PRESIDENT. "His Grace, the Archbishop of Malta has the honor" etcetera, etcetera . . . Now . . . "He regrets to inform His Holiness of certain grave derelictions, occurring within his jurisdiction, but not subject to his control." [*Anger begins to mount in the* GRAND MASTER, *and also in*

CARAVAGGIO. *He raps with a paintbrush. They pay no attention.*]

He is rather wordy; I shall summarize . . . Knights of the German Langue are believed to favor the contumacious doctrines of the heretic Luther . . . [*The* GRAND MASTER'S *chest begins to heave;* CARAVAGGIO *stands, exasperated.*]

Agents of the Grand Inquisitor attempted to enter the Auberge of the Langue of Provence, where certain books on the proscribed list were said to be hidden, and were denied entry . . .

GRAND MASTER [*he has begun to tap his gloved hand with his mace.*] Quite rightly!

LORD PRESIDENT. In summary, Malta, which once stood as a bastion of Christ against the infidels, may be said to have sunk in recent years, until, under the present Grand Master, it is nothing more than a slave market, operated . . ."

GRAND MASTER [*pounding his mace against his glove*]. Oh! What does he seek to gain by these lies?

LORD PRESIDENT. Mastery over Malta?

GRAND MASTER. No!

LORD PRESIDENT. Control of our Sovereign Order?

GRAND MASTER. Never, while I am Grand Master. [*He has swung wholly out of position.* CARAVAGGIO *hurls down his paintbrush. They look up, startled.*]

CARAVAGGIO. How am I suppose to paint when you go on moving!

GRAND MASTER. What!

CARAVAGGIO. You heard me.

GRAND MASTER. No one, no one is entitled . . . [*He resumes his pose.*] You may continue.

CARAVAGGIO. Not now. [*Pause.*]

GRAND MASTER [*controlling himself with difficulty*]. Very well.
Then the Lord President and I may make use of the time
you have permitted us. [*He motions to the* PAGE. *The* PAGE
*lays down the helmet, and, kneeling, begins to unbuckle a
leg-plate.*]
 When I think of that scheming Archbishop . . . First he
imports the Jesuits, just to weaken us! Then he stirs up the
Grand Inquisitor with some nonsense about forbidden
books. Now, he sets out to poison the mind of the Holy
Father . . .
 [*He wrenches his leg free.*] IDIOT! Will you never
learn! . . . First the poleyns, then the greaves! [*The* PAGE,
crushed, begins to loosen the knee-guards.]
 You, who seek to be a Knight of Malta! How many
times must I tell you! The Knight must be prepared at
every moment; remember that! You place the life of your
Master in peril if you forget!
 [*The* PAGE *nods, weeping silently. He works to undo
the leg-plates. He takes off the sabatons and places the
GRAND MASTER's feet in soft slippers. The GRAND MASTER
speaks alternately to the PAGE and the LORD PRESIDENT.*]
Next the tasses . . . I have spent hours training this lad,
although you'd never know it. Now the pauldrons . . .
that's it . . .
 [*In a low voice.*] Control yourself; control yourself in
the presence of our guests! Tears are for women! . . . Now
the back plate . . . The boy has much to learn, much to
learn . . . Now the breast plate . . . that's better . . . [*He
hands the mace to the* PAGE.] Tell the Lord President what
the mace stands for!

PAGE [*barely controlling his tears.*] The mace . . . the mace is
the symbol of courage.

GRAND MASTER [*he holds out his arms and as the exchange
continues, the* PAGE *takes off the couters and the vam-
braces.*] Correct! and the helmet?

PAGE. The helmet . . . is the symbol of modesty.

GRAND MASTER. Correct! And the sword?

PAGE. The sword, with its cross butt . . . is the symbol of the agony of Our Lord . . . and a reminder . . . that we must die for him . . . if need be.

GRAND MASTER. Correct! [*The* PAGE *takes off the* GRAND MASTER's *gauntlets and gloves. He holds out a velvet jacket; the* GRAND MASTER *slips into it.*] And the hauberk?

PAGE. The hauberk . . . the hauberk . . .

GRAND MASTER [*in a low voice*]. Imbecile! [*He speaks in a loud voice. The* PAGE *mumbles the words.*] The hauberk is the spiritual panoply that protects the knight against the frailities of the flesh!

[*In a low voice.*] You'll know it by heart tomorrow morning or you'll bear the consequences!

[*To the* LORD PRESIDENT.] Come! We'll see how many guards we can find asleep at their posts. [*They start to leave. The* PAGE *follows them.*]

CARAVAGGIO. If I may keep the page . . . for one moment . . . There's an area between the helmet and his head . . .

GRAND MASTER [*after a moment of faint suspicion*]. For a short time then, until we return.

[*To the* LORD PRESIDENT, *as they leave.*] Well . . . We must prepare a sauce for the Archbishop's goose!

LORD PRESIDENT. With a pinch of sublimate in it!

GRAND MASTER. We'll send off our own man in a fast galley. He'll overtake the Archbishop's messenger and get to Rome in time to acquaint the Pontiff with our side of the story before that scoundrel . . .

PAGE [*uneasily*]. I have much to do.

CARAVAGGIO [*at his easel*]. I too. [*He motions to the* PAGE *to raise his arm, to tilt his head. He starts to paint; he pauses.*]

Your cheek . . . It's shining . . . [*He moves close to the*

PAGE.] It's wet ... [*His mood alters. He brushes, then strokes the* PAGE's *cheek.*] Your master was cruel to you. As mine was to me.

PAGE. He loves me!

CARAVAGGIO [*returning to his easel*]. I wanted to kill him. Instead, I ran away. To Rome.

PAGE. I'll tell you, I'll tell you how much he loves me! He won't let me take my turn with the other pages, tasting his food before he eats it. Or his wine. It was in the wine that they put the poison the last time they tried to murder him.

CARAVAGGIO. The page died. [*The* PAGE *nods.*] He let a boy die for him. [*He moves to the* PAGE's *side. He tips the helmet; he adjusts the* GRAND MASTER's *robe; he pulls up the* PAGE's *stockings. The* PAGE *stands uneasily.*]

PAGE. My lord ... My lord was just my age ... when he came to Malta. He was far off ... in Piccardy. But ... But when he heard that thirty thousand Turks were laying ... were laying siege to the home of the Knights ... he rushed here to join in the battle. It was our finest hour and he ... he was a part of it.

CARAVAGGIO [*returning to his easel*]. As you would have been.

PAGE [*shaking his head*]. They talk for hours about the battles they fought. And in my mind, I'm far away.

CARAVAGGIO [*back at work*]. At home, thinking of your home.

PAGE. I try not to think of it.

CARAVAGGIO. You must! Every exile thinks only of his home.

PAGE. But Malta ... here, on Malta ...

CARAVAGGIO. Malta!

PAGE. We have good times here. Sometimes my lord takes me hunting with his falcons. Sometimes we ride out coursing after hares. And the bonfires; you should see the bonfires!

CARAVAGGIO. In Rome . . .

PAGE. They've been going on for . . . no one knows how long!

CARAVAGGIO. . . . on the feast days . . .

PAGE. Wherever the Knights went, they lit bonfires on the Feast Day of the Baptist. The people for miles around would gather straw from the fields. They'd pile it high, so that the flames would rise above the tallest towers. And they'd dance and feast all night, after a time of fasting.

 [CARAVAGGIO *has set his palette aside. He listens, entranced.*]

CARAVAGGIO. And now?

PAGE. Now, on the day before the Feast Day they haul five casks filled with straw and covered with pitch into the square. Armed soldiers guard them all night and all the next day. And then, after Vespers, after the *Ave Maria* is sung, the great doors of the Palace swing open. And there my lord stands, in his armor, and his scarlet robe, this robe. He holds a flaming torch, and I stand behind him. And when they see us, all the thousands of people in the square shout *hurrah!*.

CARAVAGGIO. And then?

PAGE. The Knights stand in ranks in their silver armor with their swords drawn and their banners floating. They stand in salute, and when the cheering has died, my lord raises his torch as a signal. The escorts sound a fanfare on their trumpets and a long roll on their drums. And we move down the Palace steps to the center of the square. We move there in a procession, and after us comes the Archbishop, old Gargallo, and the Senior Pilliers, each with his torch and his page. We come to the biggest cask, and the Archbishop prays before it. He prays that God, who is Light, will set our fire alight, and then, as if his prayer is answered, my lord sets his torch to the cask and it bursts into flame! The blaze is so bright! For a moment everyone

is stunned and silent. And then, everyone starts to cheer and to laugh! The others light their casks and the flames cover the whole sky! The whole sky is blazing as if the world is on fire! And we stand there, our faces roasting in the heat, our eyes smarting in the glare, our hearts pounding.

CARAVAGGIO. And then?

PAGE. All through the night the fires burn. Then, as they die down, you begin to see the stars once more. The sparks go on rising up toward the stars long after the flames have died. And then, after the old ones have gone to bed, hundreds of little bonfires are set alight in the back streets of Valetta. We run from one to another, we pages. And, as they grow smaller, we grow bolder. We start to leap over them, we leap back and forth, back and forth, until the sky turns to dawn. [*He sighs.*] Does it all seem absurd; does it all sound absurd to you?

CARAVAGGIO. No; no!

PAGE. I'm glad; I'm really glad! Do you know why?

CARAVAGGIO. Tell me why.

PAGE. Because of what my lord says.

CARAVAGGIO. What does your lord say?

PAGE. My lord says . . . that you are the greatest living painter! That is . . . that is why he . . .

CARAVAGGIO. Why he . . .

PAGE. No one is supposed to tell you yet, but I will tell you! [*With all the emphasis he can muster.*] You are to be made a Knight of Malta! [*He waits for* CARAVAGGIO's *reaction.*] A Knight of Obedience! Doesn't that please you?

CARAVAGGIO. You are all dukes and princes. I'm from your servants quarters.

PAGE. That's what the others say. But my lord won't listen! And

he will prevail! You are to be made a Knight!

CARAVAGGIO. I am? . . . Then . . . if I'm to be made a Knight . . . that means . . . the Pope will pardon me. [*He grips the* PAGE.] He'll pardon me!

PAGE. He will! I know he will ! [*They embrace, rejoicing.*]

CARAVAGGIO. And when he pardons me . . . I can return to Rome! [*The* PAGE *breaks away.*]

PAGE. You mean . . . you won't stay?

CARAVAGGIO. Stay?

PAGE. Here on Malta. That's why he's making you a Knight!

CARAVAGGIO. I . . .

PAGE. You're to live here.

CARAVAGGIO. Live here! On this God-forsaken island!

PAGE. If my Lord decrees it. You'll be bound to obey him.

CARAVAGGIO. No one binds me.

PAGE. You must obey! The punishments . . .

CARAVAGGIO. Yes! The punishments! Do you know what goes on beneath us? There are dungeons down there crawling with prisoners!

PAGE. Knights who disobeyed.

CARAVAGGIO. I stand here painting and I can hear them screaming.

PAGE. Our rules . . .

CARAVAGGIO. They're being tortured, on your master's orders.

PAGE. And you would disobey him?

CARAVAGGIO. Yes, if I had to.

PAGE. Why?

CARAVAGGIO [*He grips the* PAGE.] Rome! I have to be in Rome! It's the whole world for me! All my pride and all my longing; my only hope and my one regret. I fled from Rome after I killed Ranuccio. Now that I'm an exile even those dungeons seem like home to me. I'd go back to my cell, deep down in the Tor di Nona if I had to. But now . . . I won't have to! I'll go back a free man!

[*The* PAGE *has returned to the window. From now on he looks out repeatedly and speaks with increasing urgency.*]

PAGE. You'll go alone?

CARAVAGGIO. Of course. I'll stay until my pardon comes. Then, I'll be gone. I'll sail on the fastest galley to Civitavecchia. I'll hire the fastest horse and flog it all the way to Rome. Cardinal Borghese will be there waiting for me . . .

PAGE. Take me.

CARAVAGGIO. A dozen dukes and princes will be waiting . . .

PAGE. Take me with you!

CARAVAGGIO . . . with their commissions . . . No!

PAGE. I've never been to Rome.

CARAVAGGIO. You'll get there, one day.

PAGE. One day! I want to be there now!

CARAVAGGIO. You can't leave him.

PAGE. You left your master! You ran away to Rome!

CARAVAGGIO. I paid a price for what I did.

PAGE. I'll pay the price! I want to be with you!

CARAVAGGIO. With me!

PAGE. Where you go, I'll go.

CARAVAGGIO. You belong with him.

PAGE. I'm afraid of him.

CARAVAGGIO. Just because he was angry with you . . .

PAGE. It's not his anger that I'm afraid of. [*He goes to the window and looks out.*]

CARAVAGGIO. What then?

PAGE [*from the window*]. His sorrow. I'm afraid of his sorrow when he finds out how unworthy I am!

CARAVAGGIO. You're just a boy; by . . .

PAGE. They're coming!

CARAVAGGIO. . . . the time . . .

PAGE [*with increasing urgency*]. He was my age when he came to Malta! I told you that! He sees me as he was then, a hero of battles to come!

CARAVAGGIO. You may be.

PAGE. Never! I am not a great general in the making! I'm not even a soldier! I wake up crying from nightmare after nightmare of battles! When they behead the prisoners and I have to watch, I want to be sick! You heard them screaming down there in the dungeons! Well, I can't stand the thought of being tortured! I can't stand pain! [*He glances out the window.*] They're coming! . . . Take me with you!

CARAVAGGIO. No.

PAGE. You need me!

CARAVAGGIO. I can't risk it.

PAGE. You don't know how to escape from Malta; but I know! [*Voices, offstage. The* PAGE *motions. He and* CARAVAGGIO *take up their positions. They speak in low voices.*]

CARAVAGGIO. Once again . . .

PAGE. It's agreed then.

CARAVAGGIO. If we should be caught . . .

PAGE. We won't be! I know all his ways! We'll wait until you're

made a Knight. Then, when he's asleep, we'll . . .
[*The* GRAND MASTER *appears in the doorway. He and
the* LORD PRESIDENT *come into the room.*]

GRAND MASTER. Are you satisfied?

CARAVAGGIO. Your Highness?

GRAND MASTER. With the area between the helmet and the
boy's head. [CARAVAGGIO *nods.*]
 May I see what you've done? [CARAVAGGIO *bars the
way.*] As you wish . . . If I seemed a trifle harsh with you,
just now . . . you must make allowances . . . Here on Malta
. . . we lack the polish of Rome . . . [CARAVAGGIO *nods.*]
Well . . . if you've done with him . . . I'll take the boy with
me to dress me for Vespers. [*He puts his arm around the*
PAGE.]
 Were you obedient? Did you stand still? [*The* PAGE
nods looking at CARAVAGGIO. *He also nods.*] Good boy,
good boy! [*He resumes his pose beside the* PAGE.] For this
is how we shall be remembered; we two, together. The
Grand Master and His Page by Caravaggio. The Grand
Master of the Sovereign Military Order and his faithful
page.

Act II

[*The Chapel of Saint Catherine; Saint John's Church, Valetta: July, 1608.*
The Chapel is in darkness save for two lighted tapers behind the altar. The GRAND PRIOR, *clad in a monk's robe emblazoned with the Maltese Cross, sets the crucifix and the missal in place. The* LORD PRESIDENT, *also clad in a monk's robe, enters through a side door carrying an elaborate sword and scabbard, a sword belt, and the mantle of the Order.*
The two men speak in undertones as they prepare for the ceremony.]

GRAND PRIOR. You failed then.

LORD PRESIDENT. He was adamant.

GRAND PRIOR. It's a sacrilege! Some low-born painter from a village in Lombardy . . .

LORD PRESIDENT. A fugitive, a common fugitive!

GRAND PRIOR. There isn't a knight on Malta who will accept him as a brother!

LORD PRESIDENT. There is one.

GRAND PRIOR. As late as last night, the Germans were circulating a petition . . .

LORD PRESIDENT. Hush! Here they come!

[*Knights, clad in monk's robes and cowls, and carrying lighted tapers, move down the aisles of the theater and onto the stage. The* GRAND MASTER, *clad as a monk, enters through a side door followed by the* PAGE *and by* CARAVAGGIO, *clad in a white robe. The* PAGE *and* CARAVAGGIO *stand facing the* GRAND PRIOR. *The* GRAND MASTER *takes his place at the* LORD PRESIDENT's *side.*]

GRAND PRIOR. Have you attended Mass?

CARAVAGGIO. Yes, sir.

GRAND PRIOR. You have been confessed? You have received Holy Communion?

CARAVAGGIO. Yes, sir.

GRAND PRIOR. You come here freely, and you are free to withdraw. Do you now wish to do so? [CARAVAGGIO *shakes his head.*] Very well.
 [*The* GRAND PRIOR *motions to* CARAVAGGIO *to kneel.*]
Sir, why have you come before us?

CARAVAGGIO. Sir, I wish to enter into the brotherhood of the Knights of the Holy Order of Saint John of Jerusalem.

GRAND PRIOR. That which you desire is not easily achieved. It is given only to those who are held in high renown, for the nobility of their blood or for their own extraordinary merit and virtue. In your case since merit and virtue are known to us, your desire may be fulfilled, if you promise faithfully to comply with our conditions. First and above all, have you the courage to defend our Church, and our Catholic

faith with your life if need be?

CARAVAGGIO. I promise faithfully to defend them and to give my life if need be in their defense.

GRAND PRIOR. Are you resolved never to abandon our standard, knowing that if you do so you will be driven from this brotherhood to your eternal shame?
[*He departs from the ritual and speaks in an altered voice.*] You understand, do you not, that this is no empty threat. I say this because . . . because there are those who do not believe that you fully . . . [*He pauses, sensing the* GRAND MASTER'S *anger.*] If you do not die when you are driven from this brotherhood, then you will wish you were dead. [CARAVAGGIO *nods; the ritual is resumed.*]

CARAVAGGIO. I will defend the standard to my last breath.

GRAND PRIOR. Will you, at the same time consecrate yourself humbly to the service of the poor, the ill, and the persecuted?

CARAVAGGIO. I will with the aid of the Lord God.

GRAND PRIOR. Do you promise to obey the Superior assigned to you by our Grand Master, surrendering your will and your freedom to him without reservation whoever he may be?

CARAVAGGIO. I promise to renounce absolutely my freedom in this regard.

GRAND PRIOR. Remember: If at any time we find that your vows are falsely made, then you will be stripped of your robes and driven in disgrace from our brotherhood. But, as we . . . [*He glances at the* LORD PRESIDENT.] As we take your oaths to be truthful, we find you to be acceptable to our company, requiring you at all time to honor our rules, and offering you no more than bread and water, and the humblest of clothes.
[*The* PRIOR *hands out a missal.* CARAVAGGIO *places both his hands upon its open page, resting his hands upon the crucifix which it contains.*]

CARAVAGGIO. I, Michaelangelo Merisi of Caravaggio, vow to Almighty God, to the Immaculate Virgin, and to St. John the Baptist to render perfect obedience to the Superior placed over me, to live in poverty and to preserve my chastity all through the grace of God. [*The* GRAND PRIOR *embraces him.*]

GRAND PRIOR. We accept you and look upon you as one of our brothers.

CARAVAGGIO. I acknowledge myself to be one through the grace of God and the bounty of our most esteemed Grand Master. [CARAVAGGIO *kisses the missal, places it on the altar, kisses the altar, and gives the missal back to the* GRAND PRIOR. *The* GRAND PRIOR *is given and holds out a naked sword.*]

GRAND PRIOR. You have confirmed your resolution in all that is asked of you. Now, take this sword, so that you will be able to honor the promises which you have made. Place it in its scabbard and take care never to draw it against an innocent man. [CARAVAGGIO *sheathes the sword and returns it to the* GRAND PRIOR. *He hands* CARAVAGGIO *a sword belt.*]

The principal virtue of a true knight of God is chastity. As you gird your waist with this sword belt, you gird your loins, quenching your desire for the rest of your life. [CARAVAGGIO *buckles the belt on beneath his robe. He is given the scabbard and sword and attaches them to his belt. The* PRIOR *is given and holds out a mantle.*]

This is the mantle which we wear, fashioned after the one worn in the desert in a spirit of penitence by our patron, Saint John the Baptist. You will wear it in the same penitent spirit. [*The* PRIOR *shows* CARAVAGGIO *the white cross on the mantle.*]

Do you believe, my brother, that this is the symbol of the holy cross to which Jesus Christ was nailed and on which he died to redeem our sins?

CARAVAGGIO. I believe it.

GRAND PRIOR. It is also the symbol of our Holy Order which we command you to wear at all times over your heart. [*The* GRAND PRIOR *places the mantle over* CARAVAGGIO's *head and shoulders.*]

This is your yoke which according to Our Redeemer is light and will lead you to eternal life. If you bear it with patience and with charity, then the Saviour, Our Lord, will give you grace in this world and the glory of Paradise in the world to come.

CARAVAGGIO. Amen.

GRAND PRIOR. Let us pray.

[*All heads are bowed. But* CARAVAGGIO *looks up and reaches his hand out to the* PAGE. *The* PAGE *grips his hand in return. Both are unaware that the* LORD PRESIDENT *has noted their movements and is watching them. The* LORD PRESIDENT *nudges the* GRAND MASTER, *whose glance follows his own.*

[*The following lines are spoken simultaneously.*]

GRAND PRIOR [*measured and calm*]. May the Lord receive thee into the company of the faithful. And, as he has given thee the longing to uphold our vows, may He now in his infinite goodness . . . [*He glances up, frowning, at the* GRAND MASTER.] . . . may He now, in His goodness, grant thee the strength to honor them through His grace. And, even as we, His unworthy servants, pray for thee, may He in His infinite wisdom, grant thee the bliss of life eternal so that, as brotherly love has united us on earth, the goodness of God which inspires that love may reunite us in Heaven. Grant us this, oh Lord, through the merits of Thy son and our Savior, Jesus Christ, who liveth and reigneth with the Father and with the Holy Ghost, one God, world without end.

LORD PRESIDENT. You see! . . . I warned you!

GRAND MASTER. Stop the ceremony! Stop it, before he . . .

LORD PRESIDENT. . . . Too late . . . Too late! . . .

GRAND MASTER. . . . Traitor . . . Traitor! . . . Arrest him then . . . when the ceremony is over . . .

LORD PRESIDENT. On what charges?

GRAND MASTER. I . . . Have him watched then. I want them
 watched, every minute from now on. And when I catch
 them! . . . Oh, my boy, my boy! How could you have hurt
 me so!

ALL. Amen.

Act II

Scene III

[*In the Oubliette of San Angelo: 1608.*
The Oubliette is a small, underground dungeon, hollowed out of the earth and rock of the fort. It is shaped like the top of a forefinger and walled with rough boulders. It is 15 feet or so in diameter at its earthen base and about 15 feet in height. It has one small air vent leading to another dungeon and a stone cap the size of a manhole cover on its top. It is wholly dark, save for one very dim lantern.

CARAVAGGIO sits by the lantern, his back against the stone wall. He has been here in solitary confinement for nine days.

In the silence there is a far-off cry of pain.

CARAVAGGIO. Ah! [*He manages to climb off the floor and clings there, spread-eagled, his ear to the vent.*] What are you doing to him? Leave him alone, do you hear me!
 [*He lowers himself slowly to the ground and stands, leaning against the boulders. The cry sounds again. He*

climbs back to shout into the vent.] Can you hear me? . . .
I've done nothing! Nothing! So, let me out! I'll work in the
kitchens! . . . I'll row in the galleys! . . . You can't just leave
me here! . . . You can't just bury me! . . .
 [*He waits. After a time, he lowers himself again. He
slumps on the ground.*] I am a painter . . . a great painter
. . . if I ever get out of this pit . . .

[*He sleeps. There is a grating sound above him as the
cover of the Oubliette is lifted. A dim light from a lantern
shines on his bent head. A monk's habit is dropped onto the
floor. A rope ladder is lowered. A hooded* MONK *descends and
stands looking down at* CARAVAGGIO. *After a moment the*
MONK *kicks him.*]

MONK. Up, up! [CARAVAGGIO *raises himself slowly. The* MONK
 makes no effort to help him. CARAVAGGIO *stands and then
 leans against the wall for support.*] Put it on!

CARAVAGGIO. You've come from the Council.

MONK. No.

CARAVAGGIO. No? A friend then. [*He takes hold of the rope
 ladder and steps on it, he sways. He grasps at the* MONK'S
 cowl and tears it off revealing the* GRAND MASTER.]
 An enemy.

GRAND MASTER. Be silent. And climb the ladder!

CARAVAGGIO. It's dark up there. It's night. And you . . . you've
 come to kill me! [*He lowers himself slowly, clinging to
 the ladder.*] I'm staying down here!

GRAND MASTER. You do as I say! Climb, and then wait for me.

CARAVAGGIO. And then?

GRAND MASTER. You will hide in my chambers tonight. Tomor-
 row you'll be loaded onto a boat bound for Sicily.

CARAVAGGIO. Alive or dead?

GRAND MASTER. Do you think I want you dead on Malta?

CARAVAGGIO. You said I was to be tried.

GRAND MASTER. You'll be tried! For escaping without my knowledge or consent. You'll be judged and condemned; cast out of our Holy Order. By then you'll be far away.

CARAVAGGIO. Not far enough, if you choose to have me killed.

GRAND MASTER. And I should kill you. But first I should have you tortured as you tortured me. I trusted you! I staked my name as Grand Master and the name of our Order upon you. And you, you deceived me!

CARAVAGGIO. You deceived yourself.

GRAND MASTER. You stole him from me! He was all that I had of my own.

CARAVAGGIO. You had more than I.

GRAND MASTER. You took our oaths in the sacred church of Saint John. You swore on your knees to live honorably as a Christian Knight should.

CARAVAGGIO. Through the grace of God. I lacked that grace.

GRAND MASTER. You swore to render perfect obedience to me.

CARAVAGGIO. I can't be held accountable to any man.

GRAND MASTER. You swore that you would be chaste! And then . . .

CARAVAGGIO. And you! You took the same oath!
 [*The* GRAND MASTER *grips* CARAVAGGIO *by the throat and half strangles him*]

GRAND MASTER. God give me forbearance; you don't deserve to live!

CARAVAGGIO. I'll repay you! . . . I'll paint you anything you want! For nothing! A John the Baptist . . . A . . .

GRAND MASTER. All that I want from you is word of your death.

[*He thrusts a rope ladder into* CARAVAGGIO'*s hands.*] Now
. . . up!

CARAVAGGIO. When I can breathe. [*A long pause.*]

GRAND MASTER. I broke all precedent when I made you a
Knight. There was a lot of opposition in the Council. The
Germans, the Germans in particular were incensed.
They'd tried to trace your blood lines, hoping to find at
least one quartering of nobility. They found nothing, no-
thing! Not even a mayor or a privy councillor! God alone
knows what the Merisi family were doing for the past four
hundred years! [*He sighs.* CARAVAGGIO *is unable to rise.*]
 The Lord President warned me that you reeked of
treachery. So did the Grand Prior. Oh, I was warned! But, I
persisted in my blindness. I saw you as a means of bringing
a bit of Rome to this bare rock of Malta; a bit of renown, to
make up for the glory that the Order is losing, in these
damnable years of peace! So, I persisted! I made you a
Knight! I heaped riches upon you! A fine gold medallion
that the Grand Master, Valette, had handed on to me; a
sword . . . [*He shudders.*]
 That sword was worn by a hero of the Great Siege; one
who was mortally wounded by the Turks in the battle for
Saint Elmo, and who dragged himself into our chapel, to
die there beneath the altar! I gave you his sword! I did all
that for you, and you let me, knowing all the time that you
would betray me! Why, why did you betray me?

CARAVAGGIO. I had to get back to Rome.

GRAND MASTER. I would have kept you in comfort, here on
Malta.

CARAVAGGIO. I'm a painter. And there's only one city for me.

GRAND MASTER. You'd lie to get back there.

CARAVAGGIO. Yes.

GRAND MASTER. And cheat. And steal.

CARAVAGGIO. Yes, yes.

GRAND MASTER. And betray your trust. And swear, falsely, to our sacred oaths.

CARAVAGGIO. And more . . . much more.

GRAND MASTER. As if our sacred oaths were nothing! And all that we stand for, all that we live by, nothing! Honor and loyalty and faith and dedication; nothing, nothing! . . . I don't believe it! You're lying to me! Why? One of our enemies put you up to it, knowing the power of our Order, and wanting to destroy us . . . The Archbishop perhaps, dangling that pardon in front of you . . . The Archbishop put you up to it . . .

CARAVAGGIO. Yes . . . yes . . .

GRAND MASTER. . . . in order to weaken and humiliate us! . . . One more of his damnable intrigues . . .

CARAVAGGIO. Yes . . . if you wish it.

GRAND MASTER. Then [*He shakes his head, trying to clear his confusion.*] . . . You lied to me before . . . You're lying now . . . I want the truth!

CARAVAGGIO. I had to get back to Rome. I knew that you could help me.

GRAND MASTER. I would have helped you in return for the paintings! You didn't have to take our vows.

CARAVAGGIO. You were the one who wanted that. It was to satisfy your pride.

GRAND MASTER. Yes, I took pride in you. But you—you took the vows. You scorned every rule we live by. Yet you wanted to be a Knight. [CARAVAGGIO *nods.*] Why? Tell me why?
 [CARAVAGGIO *pulls himself up slowly by the rope ladder.*] Now. Before I let you go.

CARAVAGGIO [*with difficulty*]. My father was a mason. We were poor.

GRAND MASTER. Poverty is no cause. The Knights of Malta serve the poor.

CARAVAGGIO. You can afford to! [*He starts to climb. The* GRAND MASTER *blocks his way.*]

GRAND MASTER. I want more!

CARAVAGGIO. I was an exile.

GRAND MASTER. We are all exiles on Malta.

CARAVAGGIO. An outcast then. [*He hangs onto the ladder.*] My greatest enemy was D'Arpino. He called himself The Cavalier. I was wandering through the streets, through the back streets of Rome, one night. And he rode past, high up above me on that splendid horse of his. He was wearing his sword and I was wearing mine. So, I challenged him. I shouted to him to dismount onto the street and to fight until one or the other of us fell. And he refused. He said, up there on his horse, that he was a Cavalier named by the Pope. He said no Cavalier would stain his sword with the blood of scum like me.

I wanted to challenge him as an equal. So that he'd have no way out. I wanted to haul him down off his horse and to lay my sword against his sword. I wanted to darken the cobblestones of Rome with that noble blood. I wanted to leave him in the gutter where he left me.

[*A long pause. The* GRAND MASTER *blows out his lamp. He holds the rope ladder to steady it.* CARAVAGGIO *slowly climbs it. In the darkness of the Oubliette the sky is moonlit.*

CARAVAGGIO *pauses at the opening of the Oubliette, blinking and staring at the moon. He speaks to himself.*]

It's still there, still bright. It's brighter on the rim than in the center. And darker around the rim than in the rest of the sky. There's grey on the moon, more grey than I remembered. Like rock, as if it were part rock, part snow.

[*To the* GRAND MASTER.] You say that all that you want from me is word of my death. You'll get it. But not yet.

Act II

[An attic in Naples: March 1610.

A small and squalid room lit by one high window, which should be in the foreground, left. Beneath the window and to one side of it, is a washstand with a tarnished mirror above it. In one background corner, there is a dirty, unmade bed. A stack of canvases on stretchers, the outer one showing a painting begun and then abandoned leans against a wall. On a table, covered by a canvas, there are a few brushes; some paints not yet prepared; a slab of cheese; a bottle of wine, half-empty; a half-eaten loaf of bread. CARAVAGGIO's sword in its scabbard hangs on a hook on the door. Near the center of the room a bare canvas four feet high and three feet wide rests on an easel which is set to catch the light from the window.

CARAVAGGIO squats on a high stool, staring at the empty canvas. His clothes are very shabby. He has grown a beard but this may not be noticeable at first, since he is facing away from the audience. He is motionless throughout the first part of this scene.

ANTONIO, *a poorly dressed boy of sixteen or so, sits, legs akimbo, on the bed. For lack of anything better to do, he is paring a piece of cheese with a rusty knife. He starts to eat a paring and pauses, alerted by something. He lays down the cheese and plucks an invisible object from his groin.*]

ANTONIO. Just as I thought, a crab. [*He examines it.*] So I caught you at last! . . . And now you're trying to get away again . . . trying to crawl home to your sisters and brothers . . . Well, this time I've got you. And I won't let you go.

[*He glances at* CARAVAGGIO.] You know what my mother uses for crabs? Goat grease! You scratch yourself a couple of times in front of my mother, and before you know it, she's heating up some goat grease . . . She gets it all thick and grey, and then she slaps it on you. She thinks she can seal the crabs up in it like raisins in a pudding. [*He exmaines the crab.*] Goat grease! I never saw the crab yet that couldn't make it out of that stuff! [*He takes the knife and begins to slice the crab. He talks mostly to himself as he slices it.*]

You know what else my mother thinks? She thinks crabs and nits are the same! That's foolish! A nit is a little louse, and a louse beds down in your long hair where he can crawl around. Now a flea, a flea likes to be cozy. Under the armpit say, or between your shirt and your belt; he's not particular. But a crab, a crab has just one place it calls home. A crab is like a boar. You come on a wild boar rooting in a field at night and right away he runs for the forest. That's where his home is beneath all the trees. Well, a crab feels the same way about your crotch as a boar feels about a forest; your hairs are like trees, it's as safe as a forest for him. [*He makes a decisive stroke with the knife. He rubs his thumb and forefinger together.*] I'm good with a knife; I like to use a knife. [*He looks up at* CARAVAGGIO.]

You know we kill a goat or two every week, my father and I. And sometimes a calf for the tavern. I hold them while my father sticks them. And once in a while, if he's feeling good, he holds them and hands me the knife. [*He*

makes a cutting gesture.] Short and swift, like that; and
kch! it's over! [*He smiles.*] My father says I'm good, a good
little butcher. What do you think of that? [*He waits.*
CARAVAGGIO *does not stir.*] You don't say anything, do
you? You don't even move. You just sit there . . . Well . . .
there is no use in my staying hour after hour when you just
sit there; so I'm off . . . I'm going!

[*Vehemently,* CARAVAGGIO *shakes his head.* ANTONIO,
who has risen, stands, uncertain.]

Why shouldn't I go? . . . It isn't as if you paid me all
that much! . . . A few pennies a day, that's all, for fetching
your bread! Why don't you fetch it yourself instead of mak-
ing me get it for you? [*He waits.* CARAVAGGIO *does not
move. After a moment,* ANTONIO *shrugs his shoulders. He
saunters around the room pausing at the table. He hacks
off a slice of cheese, impales it on his knife and eats it. He
stands over* CARAVAGGIO.]

Well? [*No response.*] You're ashamed to go out, aren't
you? [*He jerks* CARAVAGGIO's *head around so that his
scars catch the light.*] You're ashamed of all those scars
across your face! Where the bravos slashed you! Ah! [*He
thrusts* CARAVAGGIO's *head down again.*] We're used to
seeing the work of the bravos, here in Naples. [*He saunters
around the room.*]

Being a bravo is a bit like being a butcher; only it's
easier . . . You sleep half the day . . . you come out after
dark . . . You follow your master around, in case one of his
enemies wants to do a job on him. Or, if he wants a job
done . . . then . . . three or four of you do it together! [*He
stands behind* CARAVAGGIO.] You wait . . . in a doorway
. . . until your man comes down the street . . . then . . . [*He
grabs* CARAVAGGIO.] One of you grabs him around the
windpipe! Another pins back his arms . . . you take out
your knives . . . and [*A cutting gesture.*] you fix his looks
for good!

[*He releases* CARAVAGGIO.] The way they did to you
. . . I could be a good bravo . . . it's a good living . . . like I
said, I'm good with a knife . . . [*No answer.* ANTONIO *saun-*

ters on around the room. He comes upon the sword.] It's a sword! The sword of a Knight of Malta!

CARAVAGGIO. Leave it.

ANTONIO. It's sharp! . . . one good stroke with this one! . . . It cost a lot of money and you don't have a lot . . . you stole it!

CARAVAGGIO. I am a Knight.

ANTONIO. A Knight of Malta! Here, in an attic! I've seen the Knights parading on feast days! They're rich!

CARAVAGGIO. I was a Knight.

ANTONIO. I've seen them, I tell you! With their plumed helmets and their armor; their scarlet shields and their . . . [*He glances at the sword.*] . . . swords . . . Why would they make you a Knight?

CARAVAGGIO. I was a painter. The greatest living painter.

ANTONIO. Let's see your paintings then! [*He flips over a stack of canvases.*] Just a line or two . . . I could do as well . . . and this one . . .

CARAVAGGIO. I can't paint here.

ANTONIO. . . . Half-done and then slashed up . . . and this one, smashed and broken . . .

CARAVAGGIO. I can't paint.

ANTONIO. Then you're no painter. Like my father says . . .

CARAVAGGIO. Rome! I have to be in Rome!

ANTONIO. Well? Go to Rome then! What are you waiting for?

CARAVAGGIO. For the Pope . . . to pardon me.

ANTONIO. The Pope! Why would he pardon . . .

CARAVAGGIO. It's coming, I tell you! And on the day it comes I'll sail . . .

ANTONIO. It's not coming!

CARAVAGGIO. North . . . up the coast . . .

ANTONIO. It's not coming, I tell you!

CARAVAGGIO. I'll be back in Rome by . . .

ANTONIO. Right here, in Naples, is where you'll be!

CARAVAGGIO. Rome! In Rome! There are churches waiting . . .

ANTONIO. Churches!

CARAVAGGIO. Chapels and palaces; immense, bare walls! Waiting all of them to be brought to perfection! Perfected already here, [*He strikes himself.*] . . . in my head! Scenes that I used to imagine; I know them now! Eyes of assassins, inches from my own! Blood on my knuckles drawn by my own teeth! The last groan of Goliath, brought down by a boy's pebble. The first gesture of Lazarus, raised up from the dead. I know, I know now, what that gesture was! Blinding, the light was blinding! But I see!
 [ANTONIO *has moved to the door. He slips the sword back into its scabbard.* CARAVAGGIO *moves close to him.*]

ANTONIO. I should be going . . .

CARAVAGGIO. Saying I'll never get back to Rome! [*He corners* ANTONIO.] Why do you think I've lived on, here in this rat's den! With nothing to live for, nothing! No commissions, no friends, no one but a butcher's boy to bring me bread. To take my last pennies, and then to insult me. To mock me and wound me. You! [*He grips* ANTONIO *by the scrotum.*] You, with your talk about the goats and the calves you kill! Goats bleat, calves bellow when you stick your knife into them; what should I do?

ANTONIO. You're hurting me!

CARAVAGGIO. As you hurt me! Saying that my pardon will never come! [*He releases* ANTONIO. *He stands, confused.*] If it never comes . . . If I can never get to Rome, never paint again . . . Here, take my sword!

ANTONIO. No.

CARAVAGGIO. Take it! [*He thrusts the sword into* ANTONIO's *hand and pulls away the scabbard.*] You said you'd make a good bravo! You said it was easy! Well, bravos kill! Not helpless animals, men! So . . . kill me!

ANTONIO. No!

CARAVAGGIO. One stroke! You said so yourself! One stroke, and the sword is yours. [*He falls on his knees; head bent. He waits.* ANTONIO *stands, shuddering and shaking his head.*]
 Well? . . . [*He stands and grips* ANTONIO.] There's nothing to fear! No penalty. I'm an outcast, a fugitive. An enemy like Goliath. You, you can be David . . . butcher boy or bravo, warrior, hero. Hack my head off! Hold it up proud, proud of what you've done.

ANTONIO. I'm not proud.

CARAVAGGIO. No? . . . Not proud then . . . and not sorry . . . Weary, from that struggle . . . with a sword too big for you . . . with a trace of pity maybe as you look down at your victim; as you see that even he, even he suffers as he dies. Not just from the pain; not just from the shame of it. No . . . it's more. He still has a shred of belief, of belief in himself . . . and, thanks to that small shred, he wants to live . . . [*He glances around the room.*] He wants to live . . . [*He moves, fumbling, around the room.*]

ANTONIO. What are you doing?

CARAVAGGIO. You wanted me to paint you; I'll paint you!

ANTONIO. I'm scared! I'm sick!

CARAVAGGIO. Be scared and sick then! [*He snatches the mirror off the wall and glances at himself. He goes to the table and daubs some dry red paint onto the center of his forehead.*] As David was! [*He places the mirror on the floor, leaning it against the washstand of the stool. He kneels in*

front of it.] Come here! . . . stand over me! . . . take hold of my hair . . . Now! . . . Hold me up! . . . Higher! . . .

[*The lights dim and narrow, so that* CARAVAGGIO's *head is seen as it is portrayed in his painting* David and Goliath.]

So that I can see myself as I am now . . . bleeding!

Act II

[*On the beach, south of Porto Ercole: July, 1610.*
The scene is at night. caravaggio *lies motionless in the ruins of a dory. The* fisherman's wife *sits beside him bathing his face with a cloth dipped in a bucket. She works by the light of a lamp or a candle.*
As the scene opens, she looks up, startled by some sound.

fisherman's wife. Tonio? . . . Is that you? [*She waits listening.*] Four hours, he's been gone!
 [*She turns back to* caravaggio.] Hot as a furnace; and you're nothing but skin and bones ! [*She shakes her head.*] They'd better get here soon. [*She glances up again listening. She hears nothing.*] Ah! Smug in his house, the priest is! Fond of his bottle, and scared of the dark! He won't get up from his supper to be with a dying man, not unless he's rich! . . . If you were one of the rich ones, one of the merchants in town, he'd have been here an hour ago. But seeing as you're no one . . . Die in the daytime where we live or you die unconfessed.

[*Pause. She bathes* CARAVAGGIO's *face.*] Ugly little man . . . Who are you? [*No answer.* CARAVAGGIO's *painting, the* Bacchino Malato, *rises slowly in projection. As the* FISHERMAN's WIFE *continues to speak, it blends slowly into* The Musicians, The Calling of Saint Matthew, The Madonna of Loreto, *and* The Death of the Virgin.]

Not from around here . . . and you never hauled nets for a living; not with these hands. . . . Nor loaded cargoes, you're too weak for that . . . Where are you from then? . . . Where were you going? . . . Running all the way from Porto Ercole! No one runs like that, not when it's so hot! You'd have died where you fell, if they hadn't seen you . . . Lost half a day's fishing, they did, to bring you in.

On your way to Rome, that's what you kept telling them. Running all the way! . . . It's two days from here by horse and you were running! Mad from the sun you must have been or lying. Lying to cover your tracks. Like the rest of them.

Deserters, most of them that come this way. Keeping off the roads, moving along the coast. Eat all you have. Fall asleep on your floor. In the morning they're gone without even gathering up a bit of wood for your fire. . . . No help to anyone, the deserters; but then, the soldiers are worse. A deserter. Is that what you are? [*No answer. She shakes her head.*]

Heading north into the mountains, the deserters are. And you were heading south. A prisoner then. Jumped off a galley, did you? Made your way ashore? God help you then, if you were to live and they were to catch up with you.

[*She looks out again into the darkness. She hears nothing. She bathes* CARAVAGGIO's *wrists. She shakes her head.*] If you were a prisoner, you'd have the bite of the chains on your wrists. One of the poor then; nothing more. Couldn't pay your passage, so you stowed away on a ship. Gave one of the crew a *scudi* to hide you in the hold, is that it? And, when they docked in Port' Ercole, they turned you in and you had to run for it. [*She sighs.*] Thought you

could trust them, didn't you. Those ones! They'd tell you
Judas was overpaid for betraying Our Lord! A stowaway; is
that it?

[*No answer.*] Here . . . let's take a look at you. [*She
turns his head toward the light. The head of Goliath, from
the painting* David and Goliath *appears suddenly and
sharply in projection.*] How ugly you are! And how you've
suffered! Your nose, broken . . . your lips, all cracked and
blistered . . . And dear God! look at those scars! . . . Long,
long cuts on both sides! . . . That was no accident . . . No
. . . And no fight either . . . That's the work of *bravos*!
Made one of the mighty ones angry and he set his *bravos*
on you! . . . Hunted you down and now . . .

[*She stands, panic-stricken.*] . . . They're hunting you
down again! . . . That's why you were running down the
beach! . . . The *bravos* are after you; they're after you! . . .
And . . . if they track you here . . . they'll cut us up as well,
just for sheltering you!

[*She moves away from* CARAVAGGIO. *She stands,
shivering.*] And they can track you! . . . Follow your foot-
prints with a flare . . . all the way here . . . He should never
have brought you here! He should have left you where you
fell! That way, there'd be no trouble. But now . . . If some-
one comes now; if someone comes along the beach . . . I
won't know if it's Tonio come back with the priest, or the
bravos hunting you! . . . What am I to do? . . . I can't carry
you off and hide you, not by myself . . . I can't leave you
here . . .

[*She stands, glancing in every direction into the night.*
CARAVAGGIO'*s painting* The Seven Acts of Mercy *comes
slowly into projection.*]

I can't leave you now. Not now . . . not tonight . . .
[*She sits beside him.*] The night's half over . . . by morning
you'll be gone. Gone from here and our footprints will be
gone with the tide. If they come for you, we'll swear we
never saw you, the way we did with the others. [*She
bathes him again.*]

On your way to Rome! . . . No wonder you were lying!

Running from the *bravos*, weren't you? Afraid if we knew, we wouldn't take you in ... Well ... don't worry. They won't catch up with you, not tonight. ... And, you'll be out of their reach by daybreak. Dead and buried. You'll be hidden, well hidden, where no one will find you. In a grave with no name on it, whatever your name may be. [*She continues to bathe him.*

The Seven Acts of Mercy *fades slowly; Caravaggio's self-portrait from* The Martyrdom of Saint Matthew *appears slowly in projection and alone remains.*]

This First Edition
designed by George Mattingly
edited & set in Georg Trump's Trump Mediaeval
by Robert Sibley of Abracadabra
with mechanicals by Alan Bernheimer
printed & bound in the United States
by McNaughton & Gunn Lithographers
Autumn 1979